JAMES CROAK

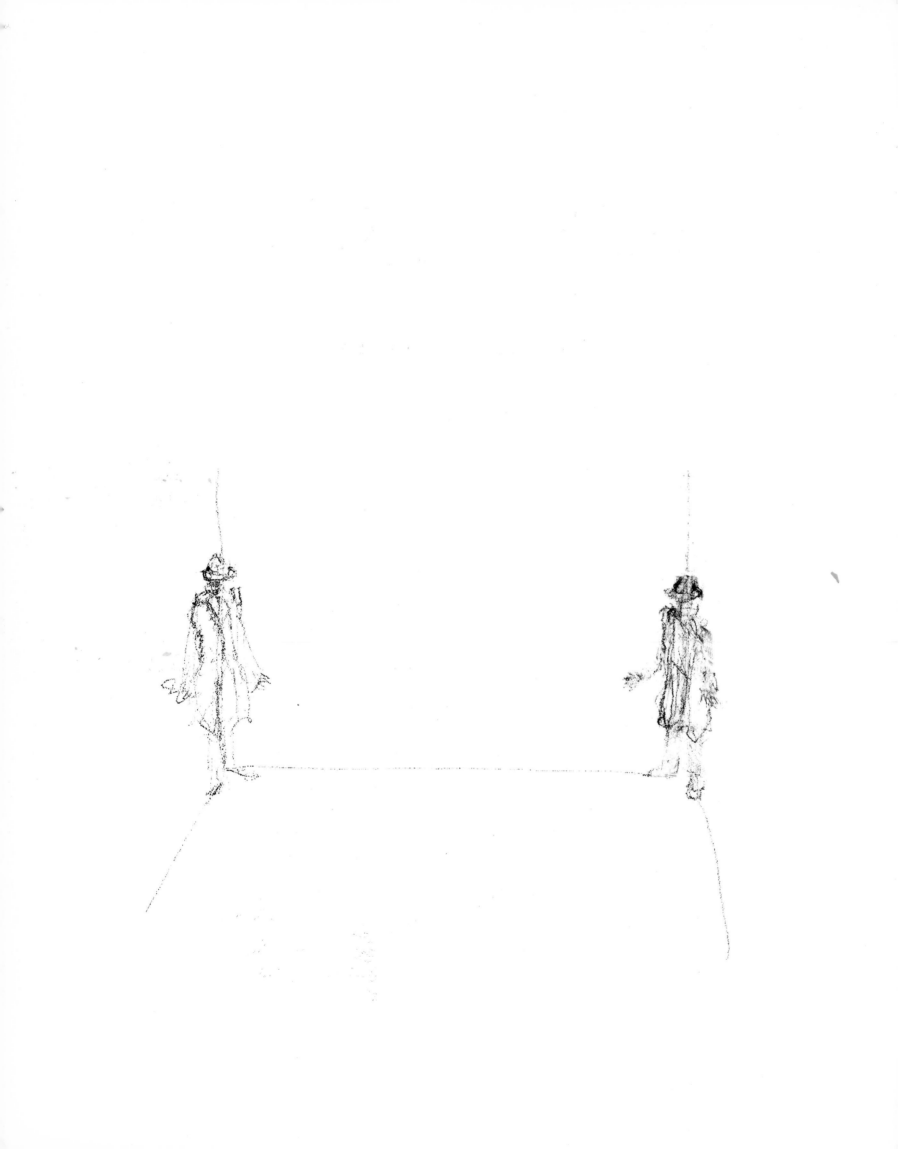

JAMES CROAK

Thomas McEvilley

HARRY N. ABRAMS, INC., PUBLISHERS

Library of Congress Catalog Card Number: 98–86858

ISBN 1–885163–06–1 (Contemporary Art Center of Virginia)

ISBN 0–8109–6379–5 (Abrams)

Published in 1999 by the Contemporary Art Center of Virginia

Distributed by Harry N. Abrams, Incorporated, New York

Editor Julie Dunn

Design Leah Roschke, San Diego, California

Printed and bound in China

Harry N. Abrams, Inc.
100 Fifth Avenue
New York, N.Y. 10011
www.abramsbooks.com

Contents

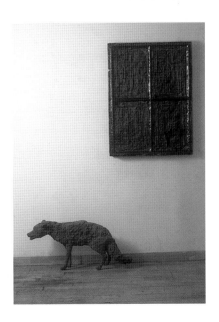

Acknowledgements

I thank the many people who made this book possible:

Barbara J. Bloemink who initiated the project

Thomas McEvilley author

Leah Roschke book designer

Carla Marie Hanzal curator

Rachel Weingeist research assistant

Elaine Stainton senior editor, Harry N. Abrams, Inc.

Peter S. Cane, esq.

Julie Dunn editor

**Rebecca Douglas, Steve Fritz & Bob Babincsak,
Robert Puglisi, and Sarah Wells**
photographers

And special thanks for their financial support:

Byron and Eileen Cohen
Mary Dinaburg
Howard Ellins
Sunny and Brad Goldberg
Paul Hertz
John and Sharon Hoffman
Dale Launer
Paul van der Spek, Galerie de la Tour, Amsterdam
Linda and Stephen Stux, Stephen Stux Gallery, New York City

Assistants:

Ayrin Leigh
Victor R. Willis II

JAMES CROAK

7

Foreword

With the rise of virtual worlds, the glut of media images and the uncertainty that comes with the end of a millennium, it is satisfying to return to what is, after all, our primary interest: humanity. Despite the rapidity of information and the multitude of new vehicles to provide it, as human beings we ask the same questions that have been asked repeatedly, century after century back into pre-history: "Why this? What is this? Who am I to be participating in it?" And especially: "How can we recognize truth?" Through technological innovation, we now have immediate access to our unknowing.

These universal queries are the mainspring of the reflective activity we call art. But today there are additional, new questions: "What will it mean to be human in the future? What is the nature of humanity that cannot be replicated or replaced by other means? How will one convey energy and life force through a work of art in the impending decades?"

For the past two decades, James Croak has been addressing these and similar questions through his work. Despite the many variations of style and subject matter that the art world has canonized during the last decades, Croak has gravitated towards realism. Whether fragments or assemblages, regardless of his unusual materials, Croak's works are irresolutely figurative; they reference more the eternal than the specific.

The closer we come to our thousand-year milepost, the more realistic Croak's work becomes: The artist invests his sculpture with a kind of post-modern excavation for meaning. The moods arising from the work—alienation, solitude, the uncanny from within the ordinary, the growing isolation of interpersonal relations—engage us beyond any individual ties to ethnicity, culture, economics, or sexual orientation.

As the world becomes more specialized, linear, digital and technological, Croak leaves all these behind. Instead, he seeks out the most mundane materials and uses them to manifest visualizations of illimitable truths.

The unusual materials the artist uses to create his sculpture heighten the implied metaphors: if humans were initially conceived from dirt/dust, and eventually disintegrate back into the earth, how more appropriate to embody the consequences of being human? How does a hand gesture—appropriated from a nineteenth-century Rodin sculpture—read to a late-twentieth-century audience?

With his continual experimentation of form and meaning, Croak offers us a means of reviewing the past and reconsidering the future.

Barbara J. Bloemink, Ph.D.

Executive Director

Contemporary Art Center of Virginia

1998

THOMAS McEVILLEY

The Sculpture of James Croak

James Croak simultaneously studied philosophy and theology at the Ecumenical Institute in Chicago and sculpture at the University of Illinois in Chicago. He graduated in 1974 as an abstract sculptor working in baroque quasi-floral extrusions of aluminum that foreshadowed modes soon to be developed by Frank Stella. In 1979 his work turned away from abstraction to figuration, with overtones of religious iconographies from various traditions and eras but mostly the ancient Near Eastern milieu from which the religions of the West developed. It has since unfolded like an ancient mythology such as Hesiod's version of early things in his *Theogony*, in which one generation of monsters replaces another repeatedly through a punctuated equilibrium gone mad.

Vegas Jesus, an assemblage or composite sculpture of 1979, shows a stuffed ram in a black tuxedo and top hat being crucified on a 10-foot-high red cross encased in a black Greek letter omega. The ram, as one reviewer noted, "symbolizes the Lamb of God,"[1] yet at the same time it symbolizes the astrological sign of Aries, which governed the age from about 2,000 to 0 B.C. and thus prepared the way for the historical birth of Christ. The Horned Beast was the principal sacrificial victim in religious practice throughout the ages of Taurus, the Bull (c. 4000-2000 B.C.), and Aries, the Ram (c. 2000-0 B.C.). In the Neolithic and early Bronze Age spirituality of the ancient Near East during that period the sacrifice of the herd animal represented the oneness of plant and animal life—the crops and the herds, mankind's two modes of sustenance at the time, both being bound by the cycling rhythms of the passing years with their ritual sequence of sex (planting), death (harvesting), and regeneration (the careful selection and hoarding of the seed grain for the next spring's planting). It was the down-to-earth symbolism of this milieu that was allegorized into a spiritual symbolism in Christianity and other mystery religions such as Mithraism.

In *Vegas Jesus* the crucifixion of the Ram suggests the end of the age of Aries and thus the birth of Christ, which marks the beginning of the age of Pisces, the Fish. The piece has a satirical quality, especially in the top hat and tux, which model the Messiah or willing sacrificial victim as a nightclub entertainer and his crucifixion as a showtime like Siegfried and Roy. A contemporary social edge to the work appears also in such details as the "Walther" banner with its association with World War II and the American survivalist motto "Free Men Own Guns." The sculpture's satirical force is aimed at the popularization of messianism on the American Right in those debased forms of Christianity that Harold Bloome has called "The American Religion."[2]

Vegas Jesus was the first of the extravagant mythological works or taxidermy pieces that constitute Croak's first generation of mythological monsters; in another sense it was the preamble to them, because the subsequent works refer to earlier moments in a mythological genealogy of which *Vegas Jesus,* though chronologically the first, represents the end-point. These works, sometimes featuring recombined elements of religious iconographies, were baroque in their exuberance at the same time that they bore a heavy weight of despairing content.

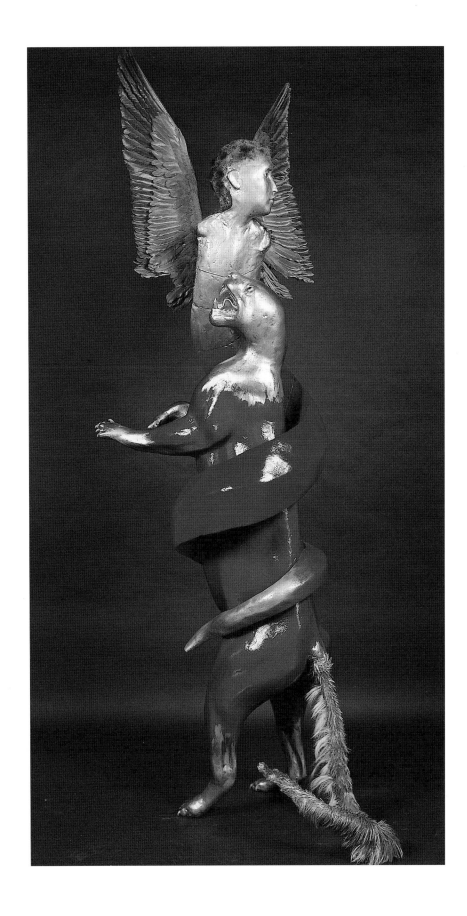

Sphinx and Leopard

1984

Later destroyed

James Croak

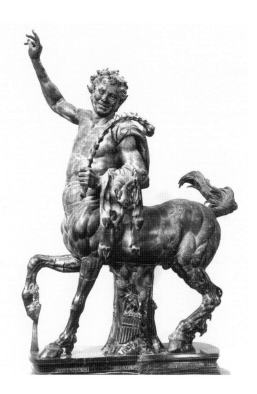

Centaur

2nd century AD

artist unknown

Musei Capitolini

Rome, Italy

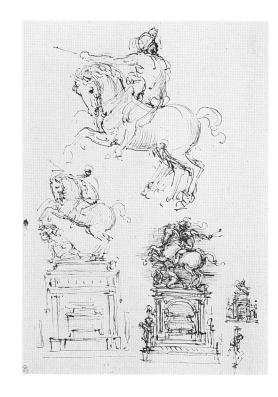

Study for the

Monument of

Trivulzio

1508-11

Leonardo da Vinci

1452-1519

Gabinetto dei Disegni

e delle Stampe

Florence, Italy

12

Beast, 1989-90, although produced ten years after *Vegas Jesus,* represents the beginning of the mythological sequence. A sculpture of a female monster that bears within it the generations of future humans—the rough beast slouching to Bethlehem to give birth—is cast dirt, that is, a casting of a mixture of soil and binder that has become a signature material of Croak's since he developed the technique in 1986. This monster is one with the earth, pregnant with future beings as the earth itself is pregnant, not only the source of crops but also, according to Hesiod, of monsters. It is a human-headed quadrupedal monster based on Greek depictions of the sphinx, with their awkwardly long front legs like the archaic lions of Delos; in the Greek tradition, unlike the Egyptian, the sphinx is ordinarily represented as female, and this monster pregnant with the future is clearly so. Such composite monsters often show their evolutionary thrust from back to front, the head indicating the most advanced component. Croak's version not only has a human head in front but also has human fingers on her forepaws (fingers based on those of Michelangelo's *David,* 1501-04) and feline paws behind. Her rearmost part, her tail, also looks like a lion's. The lion (or other carnivorous feline) was the common ally of the destroying aspect of the birth- and death-giving Double Goddess; the Neolithic goddess at Catal Huyuk gives birth upon her throne even as she holds momentarily in check the leopards that in time she will release to devour what she has borne. Babylonian Ishtar was represented by a lioness, as, at times, was Greek Artemis. This tradition survived into the Renaissance, when, for example, the goddess of Justice at the apex of the *Porta della Carta* (1438-42) of the Palazzo Ducale in Venice is heraldically flanked by obedient lions. Croak's sphinxlike goddess is pregnant with the future, filled with human babies who grasp at her ribs as if looking out from a cage or cell and which, ultimately, in her leonine aspect, she will destroy. She is a

remnant of prepatriarchal theology, that of the Neolithic and early Bronze Age goddess-worshipping cultures of the ancient Near East.

Sphinx, 1982, a related work, has the head of a woman, a reptilian tail, and the legs of a goose. Such composite beasts in Greek mythology suggest rapid irrational changes of nature that confute the security of the boundaries between species; it is as if the process of change were happening so fast that the entity undergoing the change possesses the traits of two or more species at the same moment, both the species that is being left behind and that which is coming, so that it embodies in its composite monstrosity what Renaissance sculptural theorist Pomponius Gauricus, in his *De Sculptura,* 1504, called the "pregnant moment," "an instant when the past is synthesized and the

Beast

1989-90

Working photo,

piece later destroyed

James Croak

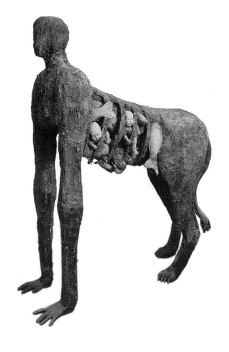

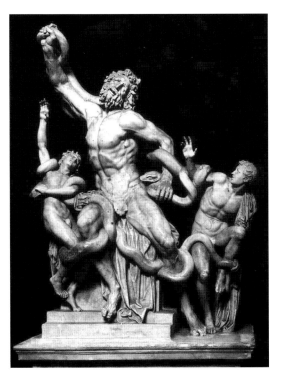

The Laocoön
Group
Roman copy
after original
100 AD
Vatican Museums

Niobe with Her
Youngest Daughter
Hellenistic
Late 4th or 3rd century BC
Florence, Italy

future suggested."[3] In *Sphinx* as in *Beast* the head represents the leading edge of evolution, the age that is dawning; the female human head shows humanity emerging from the reptilian-ornithic stages of evolution, which it still drags behind it. Croak's persistent theme—the struggle of humanity to raise itself on the Great Chain of Being—is shown here in an optimistic view (at least from a human standpoint), but in too early a stage for the optimism to be secure. The sphinx, after all, traditionally represents a question rather than an answer; it is the embodiment of the riddle of human nature, which must be answered before the teleology of human evolution and history can be understood, before man's ultimate destiny can be guessed, and before one monstrous generation can be evaluated in relation to others. It is thus a symbolic figure very relevant to the moment around 1980, when, as post-Modernism deconstructed the certainties of Modernism, the question of human nature was problematized again. Both Leon Golub and Julian Schnabel, later in the 1980s, worked with the sphinx figure as a representation of the human conundrum. From these mysterious mothers the dream and the nightmare of the future is born.

Truth, Justice, Mercy, 1983, is a centaur with a male human forepart that looks somewhat like Croak himself, ironically portrayed, as in the romantic tradition, as the artist leading onward in the process of evolution. Here the dream of the future is in full sway; the patriarchy that promotes progress as an heroic endeavor of the state has replaced the Age of the Mother, and the male, human-headed monster feels positive that he is on his way somewhere with overweening purpose. The somewhat Hobbesian natural realm it seeks to leave behind remains active in the predation of the coyote on the lynx in the wastelandlike terrain the bearer of the promise of civilization rushes to depart from. This is the realm of nature red in tooth and claw, as the lynx in turn eats a snake that eats a lizard that eats a scorpion.

In terms of the sculptural tradition Croak has conflated two genres here. One is the heroic equestrian statue as developed by Leonardo in his study for the Trivulzio monument[4] and developed to its apogee by Velasquez in the heat of the age of colonialism: the mounted warrior facing backward to summon his army—the rest of humanity—while he gestures forward toward the evolutionary goal. The other is the Hellenistic centaur, symbol of education and civilizational advance, one example of which, the so-called *Young Centaur* from Hadrian's villa, foreshadows the extended arm gesture of Croak's mock-heroic monster.[5]

Sphinx and Leopard, 1984, shows an iconic moment of cosmic evolution, a summing up of the Great Chain of Being, staged on the basis of the Orphic creation myths and related elements of Mithraic iconography. A winged human turns into a serpent in the lower half of its body. Various monsters from classical mythology are called to mind, such as Typhon, whom Zeus slew with lightning-bolt and flint sickle. "From the thighs downward [Typhon] was nothing but coiled serpents... His brutish ass-head touched the stars, his vast wings darkened the sun..."[6] The composite beast in *Sphinx and Leopard* is structurally parallel to Typhon—serpentine lower body, wings, mammalian head—but human-headed. The human head associates it also with the snake-wrapped Orphic Phanes and the Mithraic icon of Zurvan Akarana, Endless Time, also wrapped round with serpent coils.

In *Sphinx and Leopard,* the serpentine lower body is coiled round and round a lioness (a Styrofoam taxidermy form) that seems to be attempting to impede its upward ascent. Viewing the work from the point of view of iconography and the history of religions, the lioness represents the prepatriarchal energy of the goddess-religion (as in the feline hind-paws and tail of *Beast*). The angel-winged upper body of the male human hero is attempting to fly upward, but the serpentine

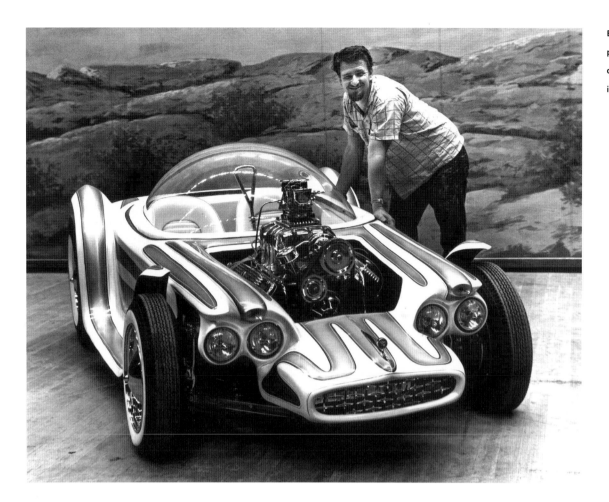

lower body, true to its Neolithic origins in goddess-religion, is collaborating with the lioness to drag it down.

Another related mythological figure is Achelous, a monster whom Heracles slew as part of his Twelve Labors. Achelous was a river god who appeared in three forms: a bull, a serpent, and a bull-headed man. Achelous challenged Heracles, was defeated, and left behind the Horn of Amaltheia, later called the cornucopia. Such composite figures, especially those involving the serpent, survive from Bronze Age clashes between matrilineal and patrilineal theologies, as in Marduk's combat with the serpent Kingu in the *Akkadian Creation Epic.* The serpentine or composite monster is the consort of the ancient goddess, whom the anthropomorphic male hero of the incoming patriarchy defeats.

From the point of view of the history of sculpture, *Sphinx and Leopard* is a monumental group of the vertical spiraling type—the *figura serpentinata*—rather than the more common triangular or pyramidal type represented by the *Laocoön* and the *Farnese Bull* group. This vertical grouping of two or more figures stacked and intertwined appeared in the archaic Greek period, in, for example, the group of Theseus lifting the Amazon Antiope onto his chariot from the archaic temple of Apollo at Eretria.[7] The format became more common in the Hellenistic era, when the arrangement of Theseus and Antiope was echoed by the Heracles and Antaeus pair in the Pitti Palace, the Niobe sheltering a Niobid in the Uffizi, and numerous other works.[8] It has Renaissance avatars such as Giambologna's *Rape of the Sabines,* 1583, and baroque ones, including several works of Bernini, such as *Faun Teased by Cupids,* 1616-17, *Aeneas, Anchises and Ascanius,* 1618-19, *Neptune and Triton,*

1620-21, *Pluto and Proserpina,* 1621-22, and above all the *Moro Fountain,* 1653-54, where the serpentine motif is handled similarly. In Bernini's use, this composition characteristically expresses an idea of transformation or change of place, and often of a conflict about this change—a usage that Croak's upward-struggling figures continue.

This generation of monsters, with its ambiguous commentary on the project of civilization and the directionality of human life, culminates mythologically in the massive post-Modern pastiche sculpture *Pegasus,* 1981-82. A full-sized 1963 Chevrolet hard-top, customized in the style of the Hot Rod culture commemorated in the car and motorcycle paintings of Big Daddy Roth and later in the Latino lowrider culture in East Los Angeles, seems to have exploded upward; its roof gapes open in a jagged hole like a tin can opened by a crude instrument not intended for the purpose. From this eruption a life-size winged stallion rises upward into flight as if it were the soul coming from within the car on the upward mission that the centaur had summoned it to, or a transformation form of the car itself as it enters mythology. With this work the problem of evolutionary direction is focused directly on present-day America. The infusion of Third World (specifically Latino) cultural elements seems to have opened the America of the big car up to an unprecedented urge to flight. The Pegasus surges upward as the human half of the monster in *Sphinx and Leopard* struggles to ascend into flight also; as the lioness holds the angel-headed monster to the earth, so the automobile may weigh Pegasus down, his wings futilely and frantically struggling to rise above the heavy realm of earthen materiality.

• • •

THOUGH HIS WORK INVOLVES THE LATE AND POST-MODERNIST USE OF found objects and materials, such as the car in *Pegasus,* Croak has remained unusually committed to the traditional modes of sculpture, especially modeling and casting. Rejecting the mode of bronze casting as too closely adhering to tradition, he invented, around 1985, a means of casting an amalgam of soil and binder to make "dirt" sculptures. In 1986 Croak began the Dirt Men, of which sixteen have been made, and shortly thereafter the Dirt Baby series, of which there now are thirty-five examples. Croak never practices life-casting, which he regards as producing a deathlike face and figure; each piece is hand-modeled in clay as Rodin did, then goes through the casting process.

The material is ambiguous inconographically. On the one hand, it suggests a Neotlithic closeness to the earth, human cultural production as part of nature, and so on. On the other, it is a debased material, "dirt," which suggests a massive down-sizing of human ambition and the self-image it has been based on since the Renaissance heyday of bronze casting. The urban identification of dirt as refuse identifies the Dirt Men as the detritus of society, suggesting that humanity is at the rag-end of its time, devalued, upheld by no dreams of nobility, barely able to shuffle like a homeless person down the street of the so-called civilization he misguidedly made for himself to live in and that later became his entrapment.

The mythological reading of dirt as earth or soil—that is, as agri-cultural or fertility symbol—suggests the Hesiodic idea of a race of earth-born humans. The *Dirt Man with Dead Sphinx,* 1986-87, indicates a generational continuity with the earlier work, signifying that the race of earth-born humans comes after the race of quasi-serpentine composite monsters has perished. Whereas Hesiod locates this earth-born generation in the distant mythological past, Croak directs the image at present-day humanity. It seems that his race of humans was born of earth and now will return to earth, exhausted. There is a suggestion of fertility, of the failures of past attempts at civilization becoming the loam from which future attempts will grow, but generally the mood seems one of pathos not of hope. *Dirt Man with Shovel,* 1993, seems about to dig his own grave in the dirt from which he also was born: earth to earth. The seated or slouched Dirt Man (*Untitled,* 1986-89), who, in terms of the classical tradition of sculpture, looks most like the Capitoline *Dying Gaul,* holds a trowel and seems to have been digging into his own left leg before he slumped over from exhaustion. He is digging his grave in the earth and he is the earth in which he is digging his grave. The involution of relationship reaches a height in the dirt shovel of *Handing,* 1993. *Dirt Man with Fish,* 1985-86, has lost his identity as earth-element and has become permeable to the denizens of the water element: on the one hand, he is dissolving; on the other, he is insensibly unconscious of the intrusions of meaning from subtler, more spiritual states that flow through him and leave no trace. The *Untitled Dirt Man,* 1987, is hung on the wall like an empty coat or a suicide, or like the skin of Marsyas in the myth of Apollo's musical contest with the satyr.

The Dirt Babies may be offspring of these Dirt Men, or they may be earlier views of them, at the beginnings of their lives. Art historical-ly they are grounded putti, cherubs whose proper element is neither the ether nor the air but the earth. There is a suggestion of the impossibil-ity of transcendence, of being earth-bound, or doomed to the earth that, in Christian tradition such as Milton's *Paradise Lost,* is the realm of the Devil. The earth people are irredeemably polluted as by Original Sin; they can never rise above this pollution. The great sky eludes them forever. By their very nature they are excluded from it.

Croak's *Dirt Man with Sphinx* was his last ensemblelike narrative sculpture. After that the Dirt Men are based on the Rodinian isolation of the individual figure, like most figurative sculpture of the twentieth century, Giacometti's above all. Viewed in this mode the figure becomes an image of mankind as a whole, or the human condition, or the prop-er attitude of man, and so on. The figure returns to the purity of its own naked presence facing the world without mediation, as in the icon that began it all in the West, the *kouros*—the seventh- and sixth-century B.C. Greek form of the upright naked male figure staring ahead with a little smile at the world he is about to walk into.

The tradition of the *kouros* changed with history, and became capacious enough to stand for the whole tradition of the solitary sculp-tural figure, in its many moods, smiling or otherwise. Sculpture in ancient Greece was a close reflection of political, military, and social events. With the trauma of the Persian Wars the blissfully naive expres-sion that art historians call the "archaic smile" was wiped off the

Pegasus: Some Loves Hurt More Than Others

1982-83

James Croak

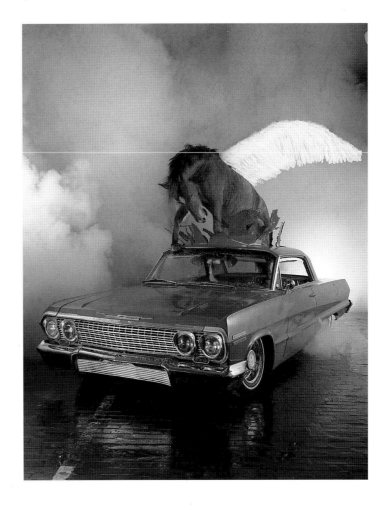

15

kouroi's faces. They became hardened by the Olympian gaze, distanced, distrustful, wary, but still gloriously in charge of their destiny. But with the Hellenistic period, with the end of the democracy and the restoration, through the Macedonian conquest, of the Bronze Age type of oriental despotism, the picture of humanity as a being in charge of its destiny breaks; a look of anguish replaces the Olympian gaze, as in the suffering figures of the *Great Altar* at Pergamum or the *Laocoön.* The body twists and bends with agonized stresses, no longer innocently erect gazing openly and incautiously outward at the oncoming world. In this lineage, which goes through nuanced stages, Croak's Dirt Men have something in common with the "Wounded Warrior" type of classical Greek sculpture—wounded, limping, but still upright.[9]

The postures of Croak's Dirt Men are ambiguous, but tend toward the same end. *Dirt Man with Shovel* seems to be standing more or less still as he looks at the spot on the ground where he is preparing to dig. *Dirt Man with Fish,* in contrast, seems to be walking in a slow shuffle of tiny steps, supported by his cane, his left foot slightly in front of the other as with a *kouros. Dirt Man with Sphinx* would also seem to be walking, in the manner of someone carrying something (not unrelated to the type of the classical *Menelaus Carrying the Body of Patroclus*).[10]

These postures are all ambiguous between standing and walking, an ancient motif of Western iconography first seen in renderings of the Egyptian pharaoh, and subsequently adopted as the stance for the *kouros.* In this hieratic posture the left foot is extended about one foot-length ahead of the right, as if walking. Yet the heels are both flat on the ground, as if not actually moving forward, and the arms hang straight at the sides as if the figure were standing still. In later Greek art the posture was developed in both directions: a stance like that of Polycleitus's *Doryphorus* suggests a contrapposto standing position; in other works the

implication of a forward striding left foot is emphasized, as in the Poseidon from Artemisium, the Theseus from the Amazonomachy pediment (perhaps from Eretria), the clay group of Zeus abducting Ganymede, from Olympia, and the Harmodius and Aristogeiton copy from Hadrian's villa.

The original pharaonic posture deliberately conflated standing still and walking—reflecting on where to go, and aggressively striding toward the decided goal. Through this posture the pharaoh was presented as in this world but not of it; he strides ahead as if a person on the earth, but at the same time is eternally still, like the Osiris-archetype of which he is the instantiation. The Greeks moved the image in both directions, toward an unambiguously standing-still posture and an unambiguously striding-forward posture.

The posture returns as a leitmotif throughout Western sculpture. Rodin's Balzac, in the *Nude Study for Balzac,* 1892, has one foot thrust ahead of the other as if walking, but both heels on the ground as if standing still. Rodin's *Walking Man,* 1876-78, despite its title, has both heels planted firmly on the ground like a *kouros,* as does his *John the Baptist,* 1875-76.

Something similar is seen in Giacometti's figures. *Man Walking,* 1947, seems to have his rear heel rising from the ground, but *Man Walking I* and *Man Walking II,* both 1960, have both heels planted firmly on the ground. Giacometti also observes the Greek practice of having female figures, like the archaic *korai,* standing with feet together, while the male figures, *kouroi,* seem, somewhat ambiguously, to be walking. In general his walking men have their arms hanging straight at their sides as if standing still, like *kouroi* or pharaohs. (As David Sylvester observed, "The style of his mature work ... deriv[ed] above all from the Egyptians.")[11]

Statue of a

Wounded Warrior

(Protesilaos)

1st century AD

Roman copy

of a Greek work

about 450-40 BC

The Metropolitan

Museum of Art

Hewitt Fund, 1925

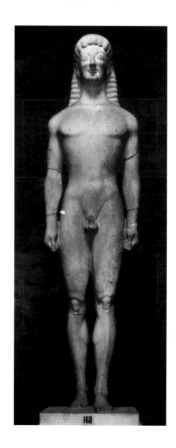

Kouros, Apollo of Tenea

c. 560 BC

Archaeological Museum

Delphi, Greece

It is in this five thousand year-long tradition that Croak's standing/walking figures should be seen, but with a difference. The narrative underlying the ancient figures involves walking toward a goal, the theme of evolutionary advance. The *kouros* in general seems to be thinking about what he is going to do, and, motivated by his reflection, just beginning to do it. The *Doryphorus* is widely interpreted as an athlete who has walked to the front of the arena to be crowned with laurel after his victorious throw. He too, though pictured just after his walking rather than just before it, expresses the theme of goal-oriented action and movement toward a goal. But in Croak's Dirt Men the hesitation between standing and walking seems to express exhaustion. These figures have walked about as far as they can go. They are on the verge of collapsing and, like the slouched Dirt Man of *Untitled,* leaking their life force into the earth or onto the pavement. They are pictured at the end of their walking, not at the beginning of it. They are posthistorical, not protohistorical. They are more about returning to the earth than emerging from it. Like Michelangelo's *Slaves* that, "within the matrix of the primordial block ... evoke humanity bound to its earthliness,"[12] the Dirt Men, through their literally earthen materiality, do the same. Croak might have preferred to be directing his work, as Michelangelo and others of his day did, toward the triumphant anthropocentrism of Pico della Mirandola's *Oratio de digni-*

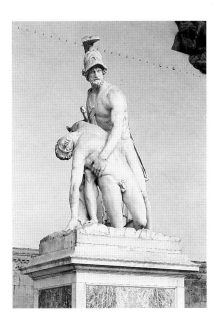

Menelaus Carrying the

Body of Patroclus

Roman copy

Original c. 150-125 BC

Loggia dei Lanzi

Florence, Italy

tate hominis (*Oration on the Dignity of Man,* 1486) but by the time the Dirt Men shuffled onto the scene there was not so much dignity left. The isolation of the human from other animal species that was assumed in Renaissance humanism no longer obtains; the boundaries between nature and culture are breaking down and mankind is losing definition and morphing into monstrous new identities. The Dirt Men shuffle onto the scene not even to wait for Godot, but merely to look for a soft place to dig a hole to sink into.

• • •

IN 1991 AND 1992 CROAK MADE CAST-DIRT SCULPTURES OF WINDOWS IN a number of styles, each different from the others. They range from arched Renaissance-evocative lunettes and narrow leaded-glass verticals as in a church to conventional home window-sashes; some that are rectangular and without internal division look like framed pictures. Viewed in art critical terms they propose a synthesis of twentieth-century tendencies: both painting and sculpture, both art work and everyday object, both abstraction and representation, they refer obliquely to the earthwork and the surrealistic object. They embody the way, at the end of Modernism, its categories were dissolving, a process which post-Modernism hastened on its way.

Viewed art historically the windows look back to precedents from the Modernist era. Duchamp's *Fresh Widow,* 1920, was a window sash with casement, bought whole at a construction materials store and exhibited as a sculpture. Duchamp's title puns lightly on the phrase "French Window," and implies that the widow's husband jumped or fell or was pushed out the window to his death. The window figures here more as an exit from some implied confinement than as an aperture to see through (the panes are painted black). It implies the larger thematics of bailing out of Modernism, as Duchamp did with the Readymades, or even bailing out of art into an unspecified alternative or out of ordinary life into some beyond.

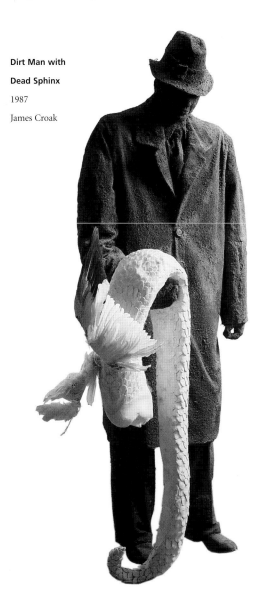

Dirt Man with

Dead Sphinx

1987

James Croak

Thomas McEvilley

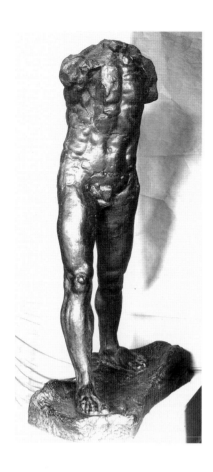

The Walking Man
(L'Homme qui Marche)
1877
Auguste Rodin
1840-1917
Musée Rodin
Paris, France

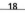
18

The motif is echoed by Yves Klein's *Leap into the Void,* 1961, a photograph that shows the artist leaping, apparently into flight, from a second-story window ledge. The piece was an icon of transcendence, or of the urge to escape the limitations of the human condition, but with tragic overtones, as the viewer knows that the upward-gazing leaper will not in fact rise upward but will fall painfully, and with risk of injury, to the pavement below. The theme of escape into a beyond was extended by Eric Orr's lead-and-gold windows with their theme of alchemical transformation.

But escape or transcendence is not the only theme carried by the window. Jannis Kounellis's windows filled with rocks or construction debris or pieces of broken classical statuary have a different resonance. Kounellis employs the window motif more for its comment on the possibility of vision than the possibility of escape. His blocked windows suggest a blocked vision, an historical situation—Late Modernism—in which the process of artistic vision has become blocked, as in the dead-end of the monochrome painting or the minimalist sculpture. Kounellis's use of this motif harks back to the windows opening out from interior rooms onto near-infinite distant landscapes in countless Renaissance paintings. Kounellis's feeling is that the penetrating truthfulness of the Renaissance vision has been lost, the window to that infinite landscape has been blocked, the art work has turned in upon itself in the enclosed gallery or museum space (in which also the windows are usually blocked or covered).

Croak's windows seem more about malleability, reciprocal passage both inward and outward, the porosity of categories and traditions, as the Late Modernist and anti-Modernist meltdown prepares

for the post-Modernist reorientation. They function at a number of levels from folk tale motif to cultural allegory. In mythological terms they express the transformation of one generation into another as realities leap through the window, leap into the void, head for the far horizon. Through this windowness the age of animal monsters, such as the sphinx, the lioness and Pegasus, yields place to the age of the Dirt Men, as one generation of monsters is replaced by another. *Coyote and Window,* 1994, seems to show such a moment in process; the coyote has either begun an age by leaping in, or is about to end one by leaping out.

The window, in effect, provides a potential space in which internal contradiction can subsist. *Pegasus* was a massive exuberant sculptural installation that perpetrated a profound surprise with a feeling of enormous strength and confidence. It did not focus on the idea of the exhaustion of Western civilization, but on a redemptive eruption of new and previously unknown energy from within it. In a cultural sense this was the energy of the displacement of Latino culture within the United States, especially California (where Croak lived at the time), by almost unrestricted illegal immigration over the Mexican border. The winged horse explodes from the roof of the car like a new transformation of Western civilization after a fresh dose of Third World energy has given it new life and sent it rocketing upward for another exciting flight through history. On the common equation of the Third World with Nature, in the Hegelian nature-culture dichotomy, the piece suggests a resurgence of natural strength and energy in the midst of culture, the escape of this mighty being from the grip of culture, and so on. An *Aufhebung* or sublation has taken place. Western civilization, which has long regarded itself, however self-deceivingly, as the incarnation of reason and consciousness (of the Ego), has incorporated its Other either in the form of nature or of the Third World, and the inner

Man Crossing
the Street
1949
Alberto Giacometti
1901-66
ARS Kunsthaus
Zurich, Switzerland

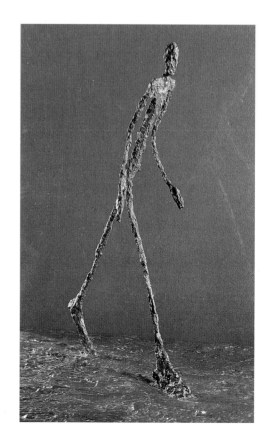

alchemical transformation of its energy has caused it to explode upward, transcendently, toward the sky, in a renewed and redirected wave of energy.

Croak's work since *Pegasus* involves the same theme to an extent, but in a mood eerily different from one of exuberance and confidence. The Dirt Men, for example, like figures in Beckett, or Magritte, or Giacometti, shuffle along as if depressed in their monochrome dark brown business suits and fedora hats. Far from the majestic ascent into the sky of Pegasus, the Dirt Men hide in their dark coloration as if hiding in the earth itself.

But their substance conveys not so much the fertility of rich loamy soil (as in Walter De Maria's *Earth Room,* say, or various works of Ana Mendieta) as the dirt of urban detritus. These men are literally made of the dirt of civilization. Unlike Pegasus, they will never escape it. The window has closed on them and, unlike the wonder horse, they are strengthless and unable to burst through the roof. Even though one Dirt Man's shovel suggests digging into the earth as if seeking a natural substrate of human nature hidden in the unconscious, and even though the fish swimming through another Dirt Man suggest the founding of humanity on the oceanic expanses of nature, still both Dirt Men seem unquestionably trapped in the slow attrition, or grinding down, of civilizations. The window through which they entered once has closed, or they have forgotten it or lost the strength to leap out through it again.

• • •

CROAK'S WORK PARTICIPATES IN THE POST-MODERNIST CRITIQUE OF history and civilization. The Dirt Men and Dirt Babies, while figurative, are nevertheless deconstructions of the tradition of cultural wholeness in which the figure exercised its selfhood and the art of the figure arose. They signify a zero-degree or end-point or meltdown of the ability of the figure to be itself, to exercise selfhood within a world where that possibility is still viable. Dregs of humanity, dregs of civilization, they persist meaninglessly for the sake of survival alone. The Dirt Man belongs in a sculptural lineage of fallen warriors and exhausted kings, wandering from his homeland into exile like the aged Oedipus entering the grove at Colonus, his selfhood hidden behind protective clothing, his cultural density so attenuated that fish swim through his body as if it did not interrupt their passage. The Dirt Babies bury their implications of new life and freshly tilled soil in a hopeless burned closure or detritus; they are the offspring of humanity too late, humanity that has lost it already, leaving survival as the last remaining option after a holocaust or other civilizational trauma.

But at the same time Croak's work belongs to tradition in a more linear or straightforward way than much post-Modernist art. It seems based on the feeling that one can still rely on tradition—or at least that one has no other option except to give up. The fact that his mature work has been exclusively figurative is significant in this regard. His figuration does not refer to debased tradition, like the post-Pop figuration of, say, Jeff Koons, or to involutions or reversals of

Fresh Widow

1920

Marcel Duchamp

Miniature French window, painted wood frame, and eight panes of glass covered with black leather

30 1/2 x 17 5/8 inches on wood sill, 3/4 x 21 x 4 inches

The Museum of Modern Art, New York

Katherine S. Dreier Bequest

Photograph © 1998

The Museum of Modern Art, New York

19

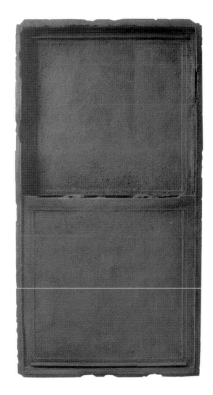

Window Series #9

1991

James Croak

historical sequences, like Mike Bidlo's "Not Brancusis" or the primitivizing chain-saw-cut figures of Georg Baselitz. The issue of sculpture is involved, or even Sculpture, meaning by the capitalization a tradition that has inscribed itself at a deep historic level in many cultural matrices, not least the Western art historical matrix. Croak's work seems residually Modernist in its acknowledgement of a kind of transcendent status to art, or at any rate to Sculpture. Even though he presents a posthistorical humanity disguising itself among the garbage of a lost or ruined civilization, still, his work is driven at a more fundamental level by a belief in the ongoing validity of the sculptural tradition in and by itself.

Thomas McEvilley

Whatever its lowdown lowrider contents, his work remains the art of the figure, it remains Sculpture, in the sense of belonging in the tradition that extends from Michelangelo to Rodin and not desiring to deconstruct or problematize that tradition but to sustain and extend it. In this sense the work is not inwardly broken and in disarray, as, seemingly, is the civilization it portrays. It knows where it belongs, and that is within a vast historical sequencing but not a universal one. It is specifically the tradition of Western sculpture per se: Pheidias, Polycleitus, Praxiteles, Myron, Lysippus, Donatello, Ghiberti, Michelangelo, Canova, Rodin, Giacometti—basically the tradition of the *kouros.* There is virtually no cross-cultural pastiche, no reference to African or Asian sculpture, no light sampling of traditions or use of references to traditions as vocabulary elements or mosaic fragments. When Gino DeDomenicis, for example, invokes Sumerian sculpture in his work he does so to make a statement about the origins of civilization and an underlying secret identity of the West, not because he feels that his work and the Sumerian are mutually embraced by a tight and uncompromising linkage of art historical tradition. Croak would not bring in a reference from so far outside his work, even if it could reasonably be invoked as lying in the background of that work at some greater distance. His sense of the coherence of tradition is still too strong for that.

In a sense the window serves a double purpose here, both to allow a transitional space for internal contradiction within the work and also to mediate between the work itself and the outside world. Croak's work seems to involve an acceptance of the tradition of Western figurative sculpture as still generative, still alive and able to beget new life, still, in terms of the integrity of its inner life force, whole—and here a question rises. Does his acceptance of the still-viable wholeness of the figurative tradition not imply some degree of belief in the wholeness of the humanity in whose image the figurative sculpture is begotten? On this point the work maintains a reserved silence as if embarrassed by the rawness of the admission requested. The work is based, in Derrida's terms, on the end of the metaphysics of presence or, in Foucault's terms, the end of humanity. At least it presents humanity as very nearly extinct, in extreme disarray, in tatters, abject, homeless, wandering aimlessly, goalless as the amoeba's motivation of mere survival. Yet it presents it in a representation, a figuration, a mode, that strives to elevate the situation by injecting its own wholeness or integrity as tradition. By its faithful invocation of tradition, the work attempts to salvage something from the devastating situation it portrays. In this way it participates in a residual Modernist motive that may be hidden in much post-Modernist work: that of redemption.

But here too there is ambiguity. The conjunction of images of brokenness with an assertion of the wholeness of the mode of imaging their brokenness may point toward a redemptive situation in which movement or affect is possible; there are overtones of the Eucharist feast—that life is broken but one can eat of the brokenness and be

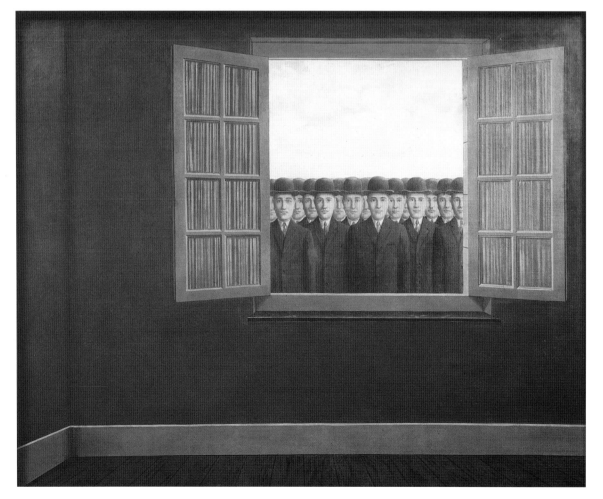

Le Mois des Vendanges

1959

René Magritte

1898-1967

Private collection

Paris, France

made whole. But on the other hand it may just point to a situation of irredeemable paradox that is inherently tragic and uses the ploy of tragic nobility to ward off open expressions of despair. Ghostly forms brush by one another, flying in or out the window.

• • •

IN THE MYTHOLOGICAL AND DIRT SERIES, CROAK HAS TRACED HUMAN-ity from its primordial beginnings to a moment that seems to presage its coming end, without portraying it at a moment of triumph or culmination in between. The triumph or culmination of its narrative may be still in its future, but that possibility is deeply problematized, a dark cloud of doubt hanging over it. This is the situation that Croak's third major series of sculptures—or generation of monsters—comments on.

The title of the series *New Skins for Coming Monstrosities,* mostly 1995, reinforces the stratification of Croak's oeuvre as a series of generations of monsters. The concept "new skins" suggests that the indwelling spirit or life-force remains in some way the same from one generation to the next, only being processed through a sequence of monstrous outer husks; yet this processing seems evolutionary to a degree—or devolutionary—, the inner spirit rising or sinking in some kind of cosmic hierarchy or chain of being through its outer transformations. This series of transformations does not seem to be very hopeful. True to evolutionary theory, Croak refers to the garment- or skin-like works as survival strategies for desperate situations, as a threatened species adapts to its peril through developing protective colorations or other such strategies. By the mid-1990s Croak's work dealt openly with the issue of mere survival—no revivifying and transformative explosion of energy, no more heroic centaur pointing the way or mighty Pegasus bursting through the roof, but exhausted and desperate survival strategies in a hopeless situation. *Trash Suit,* 1995, is a cast latex human skin, or skinlike garment, or camouflage skin, lying on the floor (the pavement) as if it were a person naked and partially covered with trash. Socially the work refers to increasing violence against homeless people or, more broadly, to the Modern experience of anxiety leading to panic creating the feeling of wanting to dive under something for cover and safety. If you are the trash of society, fair prey for random urban violence, or a member of an evolutionary loser species, the suggestion is, you might as well cover yourself with trash and hide beneath it while sleeping in hopes your natural enemies will not recognize your presence. Ashes to ashes, trash to trash.

Interpersonal Relationship Suit, 1995, extends the danger zone to everyone not living in total seclusion. Life-size cast latex covered with pebbles embedded in the latex, the suit is like a coat of armor inexplicably hanging on the wall. The context or warfare for which this armor is to be worn is simply the everyday interpersonal relationship. Humans, it is implied, are a generation of monsters so dangerous to one another that one should not enter a relationship without arming oneself against psychological, emotional, and even physical aggression—like hiding under trash.

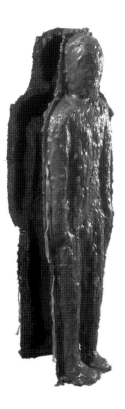

Child Skin

1995

James Croak

West Family collection

at SEI Investments

Decentered Skin and *Child Skin,* both 1995, are cast latex, rubber, and dirt, yet they actually look like the moulds themselves, not the casts made from the moulds. They stand upright and hollow and open, as if inviting a wandering and homeless soul to enter and take refuge there. There is an association with the Orphic idea of the body as the prison in which the soul is confined, yet the emotional charge is reversed. In the Orphic tradition the opened body, revealing the inner hollowness left behind by the soul that fled, would be a celebratory icon, indicating that the soul had escaped its limitations and ascended to its true home on high. In Croak's more historicized approach the absent but implied soul seems not freed but lost, not flying on high but wandering homeless and cold in a lonely wind that it has no protection against. The invitation to enter the empty body is double edged, as it offers both refuge and vulnerability to attacks upon the flesh.

Croak's Dirt Men and hanging empty skins might be compared with Antony Gormley's life-size apparently hollow figures, but they do not involve Gormley's aspirations toward yogic purity. Though Croak's "skins" are not life-cast but modeled, their presence nevertheless recalls Yves Klein's practice of casting his associates among Les Nouveaux Realistes. But Klein painted his figures in colors aspiring to transcendence (gold and blue), and his purpose was to immortalize both himself and his cronies as a kind of heavenly court not unlike that depicted in Byzantine mosaics of Justinian and his associates against a ground of gold. Croak's figurative practice more directly recalls Ed and Nancy Kienholz's works such as *Solly 17,* 1979-80, which refers not upward toward heaven but downward toward the troubled gutters of society.

Croak's empty suits hanging on walls recall an aspect of the twentieth-century art of the figure that began with Marcel Duchamp's empty vest, extended through Joseph Beuys's gray felt suits on hangers on walls, and Marcel Broodthaers's exhibition of a folded laundered shirt. In terms of female selfhood as suggested by apparel one thinks of

the work of Judith Shea and others. This tradition in general involves a questioning of human nature—what can fill this empty suit?—but Croak's examples seem more to question human survival.

● ● ●

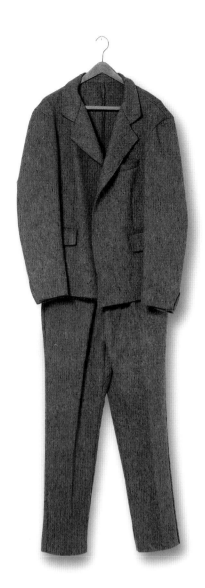

Felt Suit

1970

Joseph Beuys

1921-86

Tate Gallery

London, Great Britain

ART IS NOT PRECISELY PHILOSOPHY; NEVERTHELESS IT IS TRUE THAT, AS William Wilson wrote, "Art is a way of thinking about reality."[13] Croak's vision of the reality mankind faces today is as quizzical or jaundiced as that of any post-Modernist anti-sculptor. The output of many artists of his generation might be termed postsculptural in the sense that it reneges on the tradition of the *kouros,* that is, the art of the figure or of humanity. But in addition it has gone beyond Rilke's precept, which must have seemed universally transparent in its day, that sculpture must "distinguish itself somehow from other things, the ordinary things which everyone can touch. It must become unimpeachable, sacrosanct, separated from chance and time through which it rose isolated and miraculous..."[14] The value of verisimilitude—of looking like an ordinary object—was in one sense the greatest temptation and in another the greatest threat, a threat that had to be offset by the pedestal or monumental setting, which would separate the object "from chance and time" and protect its sacrosanctity.

Twentieth-century sculpture has radically breached this principle in several ways, above all in the tradition of the Duchampian readymade. The ordinary snow shovel hanging on a wall or coat rack positioned on a floor are made strange by their inappropriate locations, but by nothing else. Similarly the only thing designating Carl Andre's bricks as art works rather than construction materials was the gallery context. Public sited works without pedestals are set off from the ordinary only by some detail such as the lack of color, as in George Segal's life-cast figures waiting to buy a ticket at the Port Authority bus terminal in New York City. The edge is getting finer and finer.

The tradition of the readymade, or found object presented as art work, may be called anti-sculpture.[15] Herbert Read noted the situation before the term anti-sculpture had been coined, saying: "We continue to call all free-standing three-dimensional works of plastic art 'sculpture', but the modern period has seen the invention of three-dimensional works of art which are in no sense 'sculpted' or even moulded."[16] Croak's work, however, pursuant to its acknowledgement of the Michelangelo-to-Rodin lineage, has resolutely remained sculpture rather than anti-sculpture; even when it is expressing a similar sensibility of awareness of posthistorical reality, it does not become postsculptural, or antisculptural. It remains sculpture both in its technique—modeling and casting—and in its faithful adherence to the tradition of the figure, the unabashed open humanity of the *kouros.*

The existence of such sculpture today is a necessary part of post-Modern pluralism, as is painting like, say, that of Arnold Mesches, which is post-Modern in its social orientation and its quotational referentiality, but Modernist in its tenacious faith in the pure painting of the touch and the brush. The weakness of post-Modernism is its tendency to betray its own premises by becoming a new orthodoxy which excludes the elements of tradition it rebelled against.

The story is getting old and familiar. Modernism in its early stages saw itself as an antitraditional attitude that would always retain its confrontational edge. Then it lost its confrontational edge and, instead of undermining traditions, became a new tradition itself. Post-Modernism then set out to undermine the tradition of Modernism, as Modernism had once set out to undermine earlier traditions. In its early phase this new movement was not yet actually *post*-Modern; it fixated on the confrontational task of the moment and became *anti*-Modernist. As such it became a set of prohibitions against various Modernist practices: there was to be no metaphysics, no formalistically legitimated myth of progress, no cult of aesthetic feeling, no acceptance of the tyranny of historical chronology, no foundational belief system. Post-Modernism itself would be born out of a conflation of Modernism and anti-Modernism; as opposed to the system of prohibitions that made up anti-Modernism, it was supposed to have no prohibitions. Simply put, it was more or less a reappearance of traditional liberal pluralism—a position that must at one time have invigorated Modernism as well, but which Modernism had long since betrayed.

For a condition of pluralism to continue, there must be no hardening round a new consensus or canon that, merely by existing as a canon, becomes exclusionistic. It would not be truly post-Modern, or truly pluralistic, for example, to exclude sincere rather than ironic homages to Modernist tradition; indeed, residual or recurrent aspects of Modernism might legitimately appear not only as homages but as continuations (as what George Kubler in *The Shape of Time*[17] called suspended sequences that could be reopened). Mature artists still practicing Modernist approaches, from Robert Ryman and Agnes Martin in the United States to Howard Hodgkin and Lucien Freud in Britain, must be accepted as legitimate parts of a pluralistic landscape that wishes to avoid the kind of repressive homogenization that leads to consensus and canon-formation.

It could plausibly be argued, by, say, 1995 or so at the latest, that the transition between Modernist types of art (with their emphasis on aesthetic unity and sameness) and post-Modernist types of art (with emphasis on multiplicity and difference) had already been accomplished. The persistence of residual Modernists in the midst of post-Modernism was truly, for once, the exception that proved the rule—that is, the rule of pluralism.

Meanwhile, as the logic of power refused to listen to reason, a new canon was in fact forming. When the Museum of Modern Art in New York City (the paradigmatic institution of Modernist exclusionism) paid in seven figures for a suite of Cindy Sherman's *Film Stills* in 1997, one heard the death-knell ringing for pluralism. It meant that the exciting period of transition, when the cards are thrown in the air and for a moment there is breathing room for all the players, was over. The new hands had been dealt. A new canon was in place, backed by the financial, social, and art-political authority of conservative institutions. A new Mafia had grown up, and could be expected to be as jealous in the protection of its turf as any previous generation had been. It appears that the moment of freedom is over. Until this new canon has exhausted itself by holding on to its position, little that is new or interesting can be expected.

It is at such a moment that the art world is being asked to consider again the path taken by James Croak. His rootedness in tradition, alongside his awareness of the cultural omens of the moment, betokens neither Modernist nor post-Modernist exclusionism. Refusing to reject out of hand the achievements of Modernism, he refuses as well to blind himself to the manifest truths of post-Modernist skepticism and deconstruction. His work acknowledges and embodies the negative mood of this age of doubt, but refuses to give in to it completely by abjuring even the means to deal with it honestly that tradition has provided. He sees that the Renaissance dealt with as sweeping and as deep a revaluation of human identities and goals, and that art was one of its useful tools in doing so. He is not sure that the present situation is radically more insoluble than that one was.

• • •

IN CROAK'S OEUVRE THERE IS NO WHOLENESS OF NARRATIVITY. THERE are no metanarratives, unless it be the metanarrative of fragmentation and layering, the metanarrative of a wholeness straining upward to be reborn and falling into its own ashen fragments. Is Pegasus a transformation of the car, cultural energy become natural energy? Or is Pegasus trying to escape the car right before it wrecks? Is Pegasus implementing a survival strategy that looks exuberantly alive but is doomed?

By the time of *Trash Suit* the strategies of escape or real transformation no longer seem available. The vacated humanity of *Trash Suit* debases itself in a pretended transformation that is a transformation downward on the energy chain, not upward, and that is fake anyway. But then: the fact that the transformation of man into garbage is fake suggests that perhaps a pre-garbage form of man still lurks—licking its wounds, perhaps—within the trash suit, waiting for an opportunity to reappear and begin again its slow ascent upward. Trash Suit Man and his colleagues such as the shuffling Dirt Men could suggest the Orphic narrative of the soul hidden within a coating of karmic mud (*pelos*, as Socrates calls it in the *Phaedo*) a dense dirt attained through being imprisoned in the body and dragged through the back alleys of the slum of the world, that is to say: embodied life. In Socrates's vision of the meaning of life in the Phaedo the soul must cleanse itself of this barbaric dirt that keeps it reincarnating in the slum of the body. Then it can see the right direction in which to emerge from the mud of the body, like the discarded dirt suits on the wall, and ascend like Pegasus bursting winged through the barren integument of the machinery of the body.

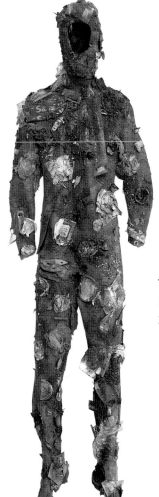

Trash Suit

1995

James Croak

Thomas McEvilley

In the narrative interconnectedness that links these works one glimpses the internal coherence of the oeuvre. Croak's work emphasizes the single figure, though traditionally it is the sculptural group that bears the weight of narrative. Rodin, for example, produced both sculptural groups such as *The Kiss,* 1882, and single figures such as *Walking Man,* 1877. The single figures were criticized in his day as incomplete because they did not reveal a narrative but remained fragments of an as yet unseen whole. The whole would have been a grouping or monument that dictated a subject matter and a specific narrativity, as in salon topics of the day such as, say, *Cupid and Psyche,* or Danaids, or, in an ancient example, the large tableauxlike grouping in which the isolated piece that we call the *Charioteer of Delphi* was included. Most of Rodin's own works of this type, such as *Eternal Spring,* 1884, and *The Kiss,* are widely regarded as his most vulgar; but in *The Age of Bronze,* 1877, *John the Baptist, Walking Man,* and *Study for Balzac, F,* 1896, he proposed a new approach in which "the sculpture is the figure, the figure is the sculpture," an approach whose axiom was "the congruent limits of the figure with the sculpture."[18] Croak has somewhat combined these two Rodinian modes. In his work there is narrativity, but it is derived from an overview of single figures, rather than from dramatic groupings. The narrative does not exist entirely in one work but in the relations among them overall.

• • •

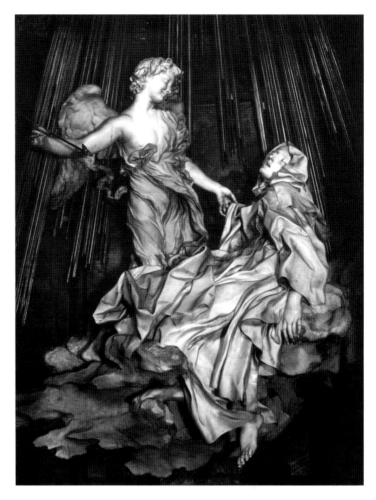

The Ecstasy of St. Theresa

1645-52

Gianlorenzo Bernini

1598-1680

Sta. Maria Della Victoria

Rome, Italy

TRADITIONAL WESTERN SCULPTURE OF THE FIGURE, FROM PHEIDIAS TO Michelangelo to Rodin, attempted to portray the soul in the body—or rather, the body ensouled. Though what one sees is ostensibly the body, it is portrayed with clear implication that the soul is present in it, informing and enlivening it and giving to it hints of divinity. In fact, at the very moment when one sees the body lying back in all its inertia, as in Bernini's *Theresa* or in ethnographic descriptions of shamanic performance, the soul may be soaring on high in realms unspeakable. This was the central point of what might be called the sculpture of presence: The soul was the essential truth of human nature and the sculptor was engaged in the portrayal—ultimately the embodiment—of that essence. There were magical or fetishistic resonances clinging round this artistic endeavor, as in the late Neoplatonic belief, enunciated by Porphyry, that the soul of the deity represented in an iconic sculpture was actually present in it.

It is one of the clearest signs of the transition from Modernism to post-Modernism that recent art of the figure has portrayed the body not as presence but as absence. The body is presented as an empty vessel, like T.S. Eliot's *Hollow Men,* "headpiece filled with straw." Either it has always been empty because that is its nature, or it has been emptied out, perhaps in anticipation of its being refilled with a new substance, perhaps just before discarding it. The more optimistic possibility, that it may have been vacated temporarily to prepare for refilling, is the implication of an older artist still deeply touched by the Modernist metaphysics of Presence—Joseph Beuys's empty felt suits for example, which seem to have been an invitation to a new age to

produce a new soul. Beuys's work was still implicitly the sculpture of Presence; he portrayed the soul by its absence, presenting the empty body as an invitation to the soul to occupy, or reoccupy, it. The empty shirts and vests of Marcel Broodthaers carry a related thematics, as do various works of Jannis Kounellis—such as those involving empty beds and shelves of statue fragments—which similarly suggest a humanity that has vacated its place so that place may be reoccupied by a redefined humanity.

This optimistic tinge is not so apparent in the sculpture of the 1980s. The puppetlike figures of Jonathon Borofsky, for example, portray a robotic humanity of empty containers, vacated husks, acting without authentic impulse, as puppets or robots might act, without free will or self-determination. There is no clear implication that it will be refilled or re-ensouled. Something similar could be said of the seated hunch-backed figures of Magdalena Abakanowicz, the empty yogic practitioners of Antony Gormley, Kiki Smith's crawling excreting women, Juan Munoz's laughing little demon men, the mechanized puppetlike figures of Paul McCarthy, the worn-out and discarded doll-

people of Mike Kelley, Robert Gober's body parts squirming to escape, Jeff Koons's wooden bears and lobotomized Playmates, Louise Bourgeois's breast- and penis-fields, and many other recent instances. All represent the human figure as empty in itself or emptied out, gutted, by experience. Perhaps it awaits a renewal by redefinition, but it is not a mood of renewal that dominates such recent figuration; nor is it a whole-hearted despair such as only whole people could feel. The moods of these representations range from frank exhaustion to a weary but clear-minded acceptance of hopelessness. Clearly, this bleak postapocalyptic vista is where the Dirt Men and empty camouflage skins of James Croak belong. They are a part of the post-Modern landscape with its ambiguous or indefinite stance toward the human future.

Is the self merely a gaseous spark or static burnoff of the chemical combination occurring in the body, just going "out" when one of the chemicals is exhausted or they all happen to dissolve apart as in what is called death? On this view, recent sculpture with its evident rejection of the myth of the soul is simply realistic; illusion has been drained from it.

Post-Modernist thinkers have taken the antisoulist tendency to the limit in such ideas as the end of history and the end of humanity that go back to early (probably Neolithic) mythologems of the Flood and the Great Year, functioning in cyclical myths of time where the end of a Great Year is followed by the beginning of a new one. But in the Christian, and in the Modernist, view, time is linear, not cyclical, and the line of time will end forever when it ends.

In the Hegelian tradition the End of History meant, more or less, the End of Modernism. This meant implicitly the end of self-conscious rational purpose to human action, either a reversion to purposeless primality (the state of nature) or a postpurposive loss of will. Numerous post-Modernist thinkers have spoken as if the end of history has already happened (again perhaps introducing hints of the cyclical myth); on this view the end is no longer something to look forward to, but something to look back upon. We—post-Modernist humanity—are what is left over after the end. And what is left over is precisely that vacated self lying like flotsam on the beach of eternity that our sculptors have been showing us so relentlessly of late. This robotic figure has no sense of what freedom is, not even enough sense to desire it. Or rather, it has realized freedom as the perfection of bondage, somewhat as B.F. Skinner meant when he wrote, "Freedom is what we call the way we feel when we do what we have been conditioned to do."[19] There can be no meaningful action from this robotic corpse, which acts only from its conditioning. As Alexander Kojéve wrote: "...the end of human Time, or History—that is, the definitive annihilation of Man properly speaking, or of the free and historical Individual—means quite simply the cessation of Action in the full sense of the term."[20]

Or is the present situation a theological *trompe l'oeil* or sleight of hand? Has the soul left the body as a husk that, while it may not be innately empty, has been emptied out for the time being so the soul can fly on high, into metaphysical realms beyond the pathetic inertia of the flesh, essentially transformative realms whence it flashes intimations of its redefined glory back into vision through the quirky suggestiveness of the flesh itself? Clearly this possibility is not emphasized in the current visual realm (or the current philosophical realm); still, a post-Modernist stance toward the future must be open and questioning. Anything can happen.

• • •

THE POINT IS THAT THE SITUATION OF THE TRANSITION FROM MOD-ernism to post-Modernism has conflicting inner currents. Croak's most recent work arises from a reflection on issues of belief or disbelief, maintenance of tradition or destruction of it, art as construction or art as destruction—"making a culture," as Croak puts it, "or continually tearing down the old one."[21] On the one hand he has imbibed the lessons of deconstruction and post-Modern skepticism in general, and the nightmarish lessons of what Hannah Arendt called "this terrible century" have not been lost on him. But, on the other hand, there is an open question about how far such issues must be pressed in order to affirm their reality in a useful way.

The deconstructivist approach was aimed primarily at the claims of knowledge that characterize a culture that feels itself to be in control of its time. These claims, with which cultures attempt to convince themselves of their ultimate legitimacy and the possibility of their permanence, amount to residual religious projections; the religious/Platonic postulation of eternal verities, for example, remains effective in ideas such as the permanence of the values of Western civilization. But ideas have historically been used to validate a nation's ambitions for hegemony over its neighbors. And such ideas have played havoc with the world's peoples more than once.

Croak sees the deconstructive impulse of post-Modernism as an instrument with which Western civilization was able, precariously, at a time of crisis, to correct its course with a desperate but accurate application of critical reason. To shift the metaphor, it was a necessary instrument, however painful, with which to lance and drain the suppurating wound of the past centuries. In terms of the world history of the last five hundred years, that wound arose from a false feeling of strength. The asseverative certainty of Western civilization, egged on meretriciously by the messianic irrationality of Christianity, caused a global pattern of wounding by stabbing thrusts of false certainty from the West. The use of knowledge claims as a tool for domination in the colonial period spread the wounding around the world. The condition was treated in the nick of time by resolute negations of false certainties. To this degree deconstruction and other skeptical procedures—and those who refined and applied them—were, in effect, heroic and redemptive.

But suppose what has been necessary to correct the course at the level of logical premises and epistemological critique has now been done: suppose that, essentially, what Lyotard called the rejection of metanarratives was all that could be achieved by philosophical methods, and that it has by now been achieved: that post-Modernist epistemology has managed, in the last forty years or so, to inculcate in the general cultural community of the Western world a rational skepticism about the possibility of the ultimacy of any foundational belief. Then the ques-

The Brave Moment

1997

Eric Fischl

b. 1948

Courtesy of the artist

tion arises what to do next. If maintained past its moment of usefulness, the deconstructive turn is in danger of becoming another mannerism, even a formalism based on the generation of elegant negations and paradoxes.

The alternative is to begin to contemplate a healing, an attempt to be at peace with one's situation that is not based on a disguised absolutism. When the workshop has fallen in, or been razed to the ground, the workmen may proceed piecemeal and patiently to gather up, assemble, and work with what is left. It was never, after all, a *tabula rasa* that post-Modernist skepticism aimed at. The idea of a truly cleansed mind involves either the angelic absolutism of the virgin birth or the cauterized mind of the catatonic. The fact that we have corrected course does not mean that we are no longer on any course, nor does the fact that the ground is shifting under our feet mean that we cannot get anywhere. Is it time to start, more modestly, making a culture again, rather than continuing to mime the redemptive moment of tearing down the past?

• • •

RODIN'S WORK HAS SEEMED LIKE KITSCH FOR HALF A CENTURY OR SO. In part it acquired this reputation due to the taboo on figurative art in the Modernist era of abstractionist Puritanism. The fact that he was especially picked for censure on grounds of the supposed vulgarity of the figure indicates how successful he had been in implementing his figurative program: he became equated in reputation with the figurative impulse, which no doubt he would have approved. But the fact that the figure was ever regarded as vulgar, or the representation of it as necessarily kitsch, must give pause. This belief was characteristic of the age of the abstract sublime, which also was an age of great wars, holocausts, subjections, and dominations—an age that devoted itself more broadly and successfully than any other in recorded history to the literal destruction of human beings in their actual bodies. An overweening contempt for embodied life characterized the age of Modernist abstraction, and the contempt for figurative sculpture seems not accidentally linked to the contempt for the living body it is based on. It is still not widely realized how transcendentalist Modernist ideology was, how oriented, like Christianity, and Platonism before it, toward the idea that the soul is inimical to the body and has as its highest destiny the transcendence of its bondage to physical form. Much Modernist abstraction was actually based on millennialist views to the effect that the body had been obsoleted and a new purely spiritual age was dawning; such feelings lay behind the work of Mondrian, Malevich, Kandinsky, the Abstract Expressionists in general, and the Platonist sculptors of pure form from Brancusi to Caro. The various Theosophical, Cabalistic, and neo-Platonist backgrounds to their oeuvres all taught that the age of the body was almost at its end, and the age of pure spirit was about to begin.[22] That was why the artist who was anticipating the imminent dawning of the new age never showed the body: it was supposedly gross and outmoded, and he was aiming at something higher.

Rodin's work had several directions but some have seen at its center the dictum that "the sculpture is the figure, the figure is the sculpture."[23] In certain of his works he attempted to break the figure away from context, narrativity, and referential accumulations, and present it isolated as itself.

This portion of his oeuvre resides above all in his focus on the individual figure, sometimes abbreviated to a walking torso, in contrast to the emphasis in the salons of his day on sculptural groups dripping with juicy narratives. The main examples include *John the Baptist, The Age of Bronze*, and perhaps above all the *Walking Man*, and *Study for Balzac F*. Though some of these figures still have narrative clinging round them because of their titles, they are sculpturally isolated, and there is a concentration of humanism in this isolation. In these few central works Rodin shows a concentration on the figure that goes back even beyond Michelangelo to the *kouros*, a figurative type that seems to have been intended, in its own context, to stand alone, as a simple statement of humanity in and by itself, without adventitious ideation or narration. Michelangelo's work, though undoubtedly humanist in its emphasis on the figure, still retained something of the feel of the sculptural group, and hence of a story-telling impulse rather than a pure

St. John the Bapist

1879-80

Auguste Rodin

1840-1917

Victoria &

Albert Museum

London, Great Britain

of reality is not regarded as a shiver from a lost whole but as a leaf, single but whole, turning in the breeze in simultaneous freshness, purity, and detail.

Rodin's use of the fragment was somewhat different. At times he regarded it as nothing, as a curiosity that might be shown to a visitor as such. But in another sense it was a curiosity that was simply the Whole—not a fragment, or a tiny but perfect detail, but a wholeness that was not tiny, not broken, not lost, simply isolated as under a conceptual microscope so as more intensely to appreciate its inexplicable yet undeniable truth. In Rodin's work (as in Nietzsche's) it has been observed that "the fragment carries with it the conceptual weight of a major vision."[24]

• • •

IN CROAK'S *HAND SERIES,* 1998, THE CAST DIRT SCULPTURES OF HANDS and arms sometimes relate directly to these fragmentary works of Rodin. *Hand Series #1,* for example, is based on the right hand of *John the Baptist. Hand Series #3,* portraying an adult hand whose index finger is clutched by an infant's hand, reminds one of *Lovers' Hands,* date unknown.[25] And in general the accumulation of fragments in *Hand Series* recalls the accumulation of hands and arms in Rodin's *Fragments,* 1912.[26]

In Croak's work as in most art since the eighteenth century the fragment carries the theme of the passing of civilizations, the brokenness of what was once whole, the end of it all—and the converse of the same theme, as in *Hand Series # 3,* the child's hand grasping the adults, which suggests a way to go on, like Aeneas leading his toddler son Julus from the burning city of Troy (*dextrae se parvus Julus,* Aeneas recounts to Dido, *inplicuit, sequiturque patrem non passibus aequis:* little Julus wound his hand in mind and followed his father with unsteady steps [Vergil, *Aeneid* II. 723-24). In Croak's work (as in Rodin's) the fragment also bears the paradoxical sense of being more whole than the whole, a condensation of essence into detail wherein the part seems to contain the whole in stripped down and highlighted meaningfulness.

Finally, in Croak's work the fragment conveys another theme that was not a part of romantic symbolism but is peculiar to the post-Modern situation; it suggests something picked up in the hope of preserving it by someone who is going around and lovingly gathering the fragments to put them together into something new. But as in Kounellis's works on this theme, there may not be enough fragments left to put the whole back again as it was—like the archeologist reconstructing a broken vase in his pottery shed. So the theme of "new monstrosities" still hangs vaguely in the air as the figurative artist in the age of genetic engineering, like a mad scientist after Armageddon, gathers pieces of this blown apart monster and that one, aiming to put them back together into something that works somehow, for something.

It is meaningful that *Hand Series #1* is based on the outstretched right arm of Rodin's *John the Baptist.* This New Testament figure assumed a special importance as a representation of humanity in the Christian tradition. The condemnation of the Arian controversy at the

confrontation with the fact of the existence of the human body or self. Even in figures seemingly desolate in their isolation, like the Slaves, there was a grouping and a narration somewhat like that of the ancient group of the *Dying Niobids;* and even in a purely solitary figure like the *David* there was a surrounding, if unseen, narrative group: the Goliath in the gleam of his eye, the Hebrew people silently backing him up, and so on. But Rodin in certain figures tried to return all the way to the *kouros* (though he might not have expressed it that way, since he thought more in terms of his Renaissance predecessors than his Greco-Roman ones).

Parallel to his isolation of the figure from the group was his isolation of the body part from the whole figure. Beginning around 1880, during work on *The Gates of Hell,* Rodin sculpted fragments of figures—mostly arms, hands, and heads. In one sense he was making fragments, and he seems to have shared the romantic love for the fragment that was based both on nostalgic longing for a beautiful thing that has been lost, and on sublime horror at the prospect of similarly losing what one still has. This would be the aesthetic of the fragment that was characteristic of the age. Or, there is the somewhat different fragment-aesthetic expressed by Ezra Pound in *Personae,* during what you might call his Archilochean-Sapphic period, where the little sliver

Hombre y mujer

1968-90

Antonio López García

b. 1936

Galeria Marlborough

Madrid, Spain

Council of Nicaea in the fourth century eliminated the Christ figure as an Everyman. Subsequently, the humanity of the Christ became exhausted by surfeit of meaning in the Gothic era and had to be avoided or approached through displacement. And in the visual tradition that displacement was easily available: John was always there like an alter ego, as a naked babe gently frolicking in the ambiance of Mary on Ann's lap, then reapproaching with tormented look to administer the rebirth rite. The arm is muscular, thrusting, demonstrative. In its reaching, pointing, stretching, and grasping it defines the character of man as active, eager to bend the world to his purposes. It points toward a new time. Yet that new time is to be approached somewhat timidly through fragments of the old. The material of Croak's isolated human arms and hands links humanity to the earth with ecological overtones, implying that human destiny is intertwined with that of the earth and will not survive it.

<p style="text-align:center">• • •</p>

MAN AND WOMAN, 1998, IS COMPOSED OF TWO LIFE-SIZE STANDING figures loosely based on a piece by Antonio Lopez Garcia, *Hombre y Mujer*, 1968-90, but with changes. The woman's face is new, as is much of the man's body. In addition, Croak has altered the man's face to bring it closer to the face of Jean d'Aier, one of the Burghers of Calais in Rodin's group of that name.

Croak's *Man and Woman* form a group, but at the same time they preserve the sense of isolation characteristic of the *kouros* and its female counterpart, the *kora*. This is achieved through an almost total elimination of narrative, the figures simply staring nakedly at the world in front of them. Significant differences from the *kouros/kora* relationship include the fact that the woman, like the man, is naked, whereas in the archaic Greek period the *kouros* was naked but the *kora* was clothed; in addition, the *kouros* was portrayed with one foot advanced as if striding or considering it, whereas the kora stood with her feet demurely together, not going anywhere. Lopez Garcia preserves a hint of these gender-role conventions in the fact that his male figure's feet are spread apart (though not striding), while the woman's are almost touching. In Croak's version the gender-role differences are erased; both the man's and the woman's feet are spread apart but positioned side by side; no one is striding or leading; they are standing still together, looking forward.

But they are not simply facing the world with wide-eyed curiosity, as were most of the *kouroi*. For one thing, Croak's man and woman are apparently middle-aged, perhaps in their fifties, whereas the *kouros* and *kora* were understood as youthful, according to the Greek ideal of

the athlete, young adults perhaps in their early twenties, still feeling the wonder of the mere fact of being a subject confronting a world-object. The meaning of the *kouros* could be characterized, in light of its chronological association with early Greek lyric poetry and pre-Socratic thought, as eager subjectivity, dawning awareness of selfhood, something like the infancy of the world or, as Bruno Snell put it, the "discovery of the mind."[27]

Croak's man and woman are very different. Middle-aged, they have been through the mill already. Their bodies and their faces show the traces of far more experience than the *kouros* shows with his innocent smile. The woman's body seems already to have experienced motherhood, her hips wide and solid, her breasts pendulous and used, her arms looking as if they had worked many hours. Likewise Croak's male figure seems to have gone through the traditional experiences of a man; the solidity of his stance looks like the strength of a worker, and his slightly defensive gaze and posture suggest experience of war.

Other revealing traits are quietly present, dimly hinting at a minimal narrative. Despite their nakedness, there is no suggestion of erotic feeling between them. They do not signify the theme of *hieros gamos*, or sacred marriage, as such sculptural couples in antiquity usually did.[28] Perhaps they have had their children already years before. And it is highly significant that they stand without *contraposto*. They are not relaxed, like figures in the Polycleitian tradition such as the two bronze warriors from Riace who seem to be idly observing some spectacle.[29] On the contrary, Croak's man and woman are not watching something at their leisure; they themselves clearly are the subject of attention. They stand with an artificial formality, not relaxed and not at ease, almost as if they were standing at attention to present themselves for inspection, or awaiting the attention of some inspector. The closest parallels in the sculptural tradition are certain Old Kingdom Egyptian groups that show a pharaoh and his wife standing in a similar posture of presentation as if they were showing up for the serious work of the world, presenting themselves to the gods who oversee such matters.[30]

In terms of Croak's oeuvre it seems indeed as if these strong, competent and sane-looking humans were offering themselves for work that needs to be done. It is the work that defines humanity, the work of its massive communal project of civilization, that they, without joy it seems, yet willingly, present themselves for. They are not clearly postcivilizational figures, like the Dirt Men. Their wills are not broken, nor are their bodies exhausted. Still, they are connected somehow with the Dirt Men. They may represent a later stage of the same generation of humanity, a stage when the figure picks itself up again from its posture of debasement and finds within itself the strength to go on.

1 Kathleen Hegarty, "Sculpture Criticized by Students," *Los Angeles Times,* "Reviews," February, 1982.

2 Harold Bloom, *The American Religion: The Emergence of the Post-Christian Nation,* New York: Simon and Schuster (A Touchstone Book), 1992.

3 Roberta J.M. Olson, *Italian Renaissance Sculpture,* London: Thames and Hudson, 1992, p. 151.

4 Ibid., fig. 116.

5 R.R.R. Smith, *Hellenistic Sculpture,* London: Thames and Hudson, 1991, fig. 162.

6 Robert Graves, *The Greek Myths,* New York: Penguin, 1981, vol. 1, p. 134.

7 See John Boardman, *Greek Sculpture: The Archaic Period,* London: Thames and Hudson, 1978, fig. 205.2.

8 Smith, *Hellenistic Sculpture,* figs. 138 and 140; see also figs. 118, 133, and 134.

9 See, for example, John Boardman, *Greek Sculpture: The Classical Period,* London: Thames and Hudson, 1985, fig. 237.

10 See Smith, *Hellenistic Sculpture,* fig. 133.

11 David Sylvester, *Looking at Giacometti,* New York: Henry Holt, (An Owl Book) p. 99.

12 Olson, Italian Renaissance Sculpture, p. 170

13 William S. Wilson III, "Art Energy and Attention," in Gregory Battcock, ed., *The New Art,* New York: E.P. Dutton and Co., 1973, p. 247.

14 Rainer Maria Rilke, *Rodin,* English translation by Jessie Lamont and Hans Trausil, London, 1949, p. 9.

15 See Thomas McEvilley, *Sculpture in the Age of Doubt,* forthcoming by Allworth Press, New York, 1999.

16 Herbert Read, *A Concise History of Modern Sculpture,* New York: Oxford University Press, 1964, pp. 14-15.

17 George Kubler, *The Shape of Time: Remarks on the History of Things,* New Haven: Yale University Press, 1962.

18 William Tucker, *The Language of Sculpture,* London: Thames and Hudson, 1974, pp. 25 and 37.

19 B.F. Skinner, *Beyond Freedom and Dignity,* New York: Alfred A. Knopf, 1971, passim.

20 Alexandre Kojéve, *Introduction to the Reading of Hegel: Lectures on the "Phenomenology of Spirit,"* Ithaca and London: Cornell University Press, 1981.

21 In a letter to the author, March 27, 1998.

22 For more on this see McEvilley, "The Opposite of Emptiness," in Thomas McEvilley, *The Exile's Return: Toward a Redefinition of Painting for the Post-Modern Era,* New York: Cambridge University Press, 1993.

23 Tucker, *The Language of Sculpture,* p. 25.

24 Rainer Crone and David Moos, in Rainer Crone and Siegfried Salzmann, eds., *Rodin: Eros and Creativity,* Munich: Prestel, 1997, p. 28.

25 Ibid., p. 54.

26 Ibid.

27 Bruno Snell, *The Discovery of the Mind: The Greek Origins of European Thought,* New York: Harper and Row (Harper Torchbook), 1960.

28 See for example the wooden plaque from Samos illustrated by Boardman, *Greek Sculpture: The Archaic Period,* fig. 50.

29 See figs. 38 and 39 in Boardman, *Greek Sculpture: The Classical Period.*

30 See for example pages 51 and 86 of Kasimierz Michalowski, *Great Sculpture of Ancient Egypt,* New York: William Morrow and Company, 1978.

New Myths and Heroic Metaphors

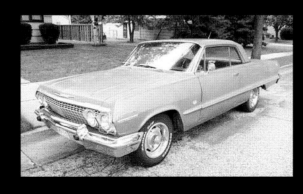

Pegasus: Some Loves Hurt More Than Others

1982-83

11 x 20 x 13 feet

'63 Chevy, horse, feathers

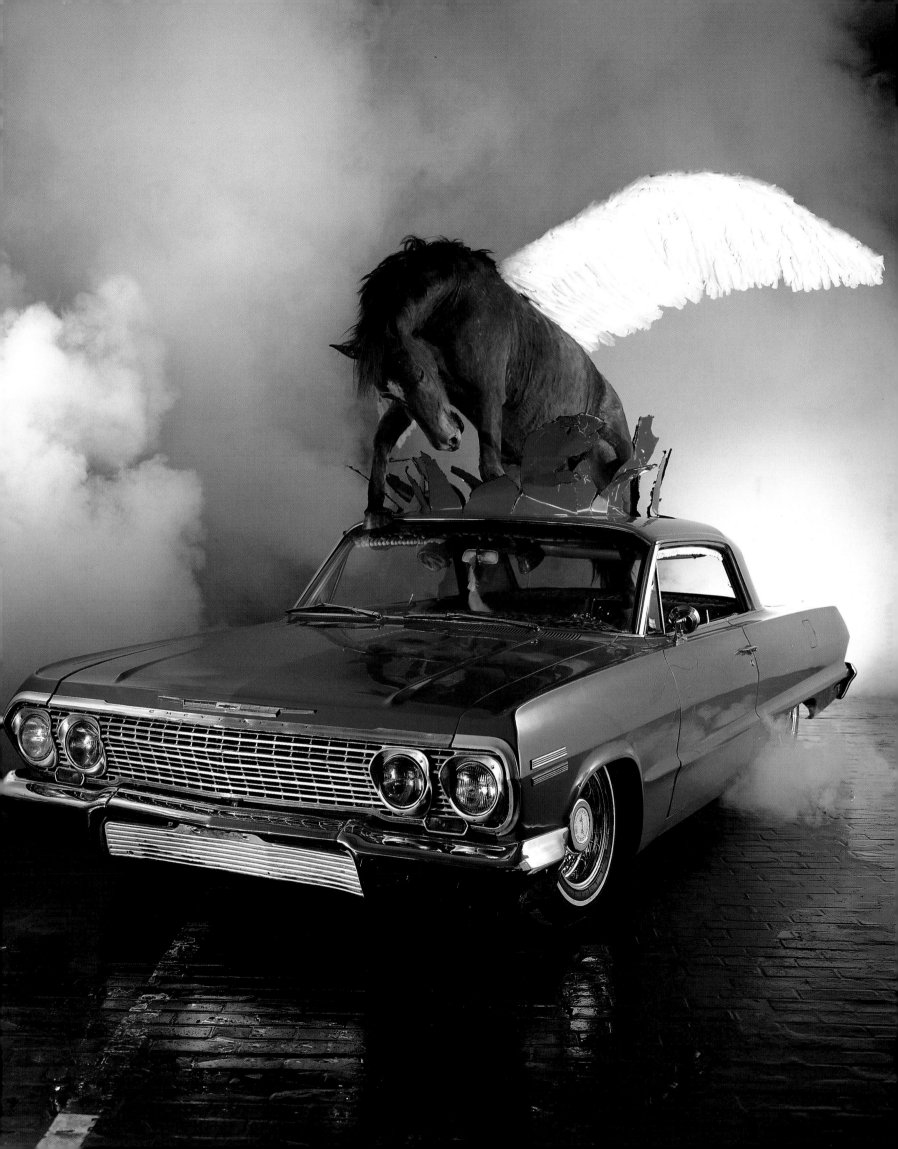

Sphinx

1982

30 x 65 x 32 inches

Cast resin, animal parts

Collection of the artist

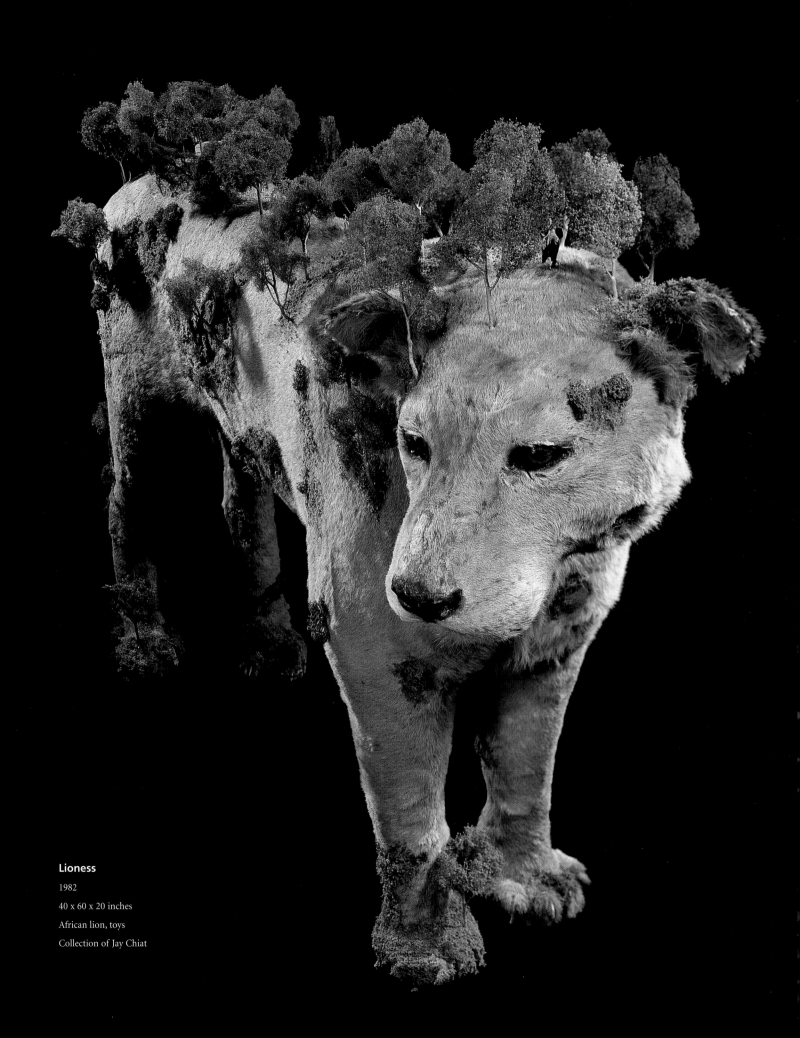

Lioness

1982

40 x 60 x 20 inches

African lion, toys

Collection of Jay Chiat

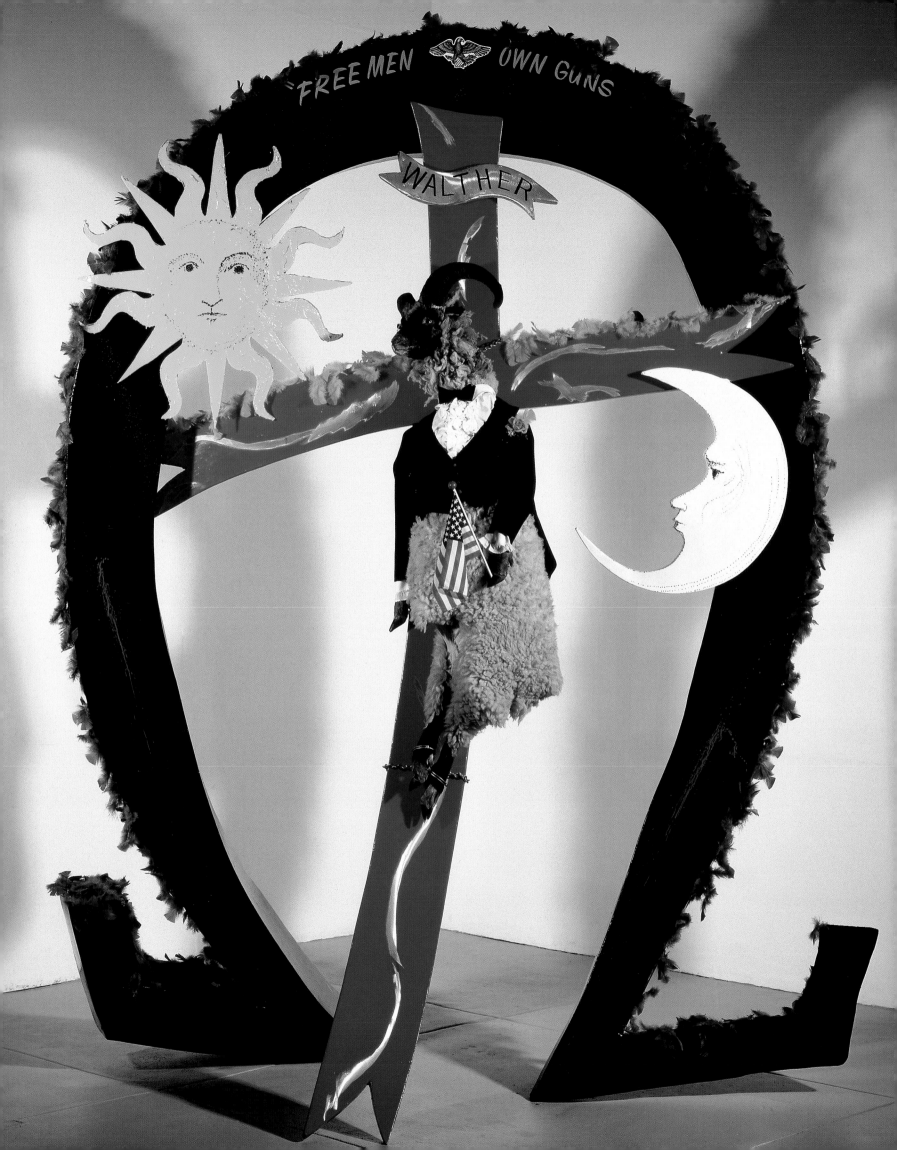

Vegas Jesus
1979-81
10 x 9 x 5 feet
Mixed media
Later destroyed

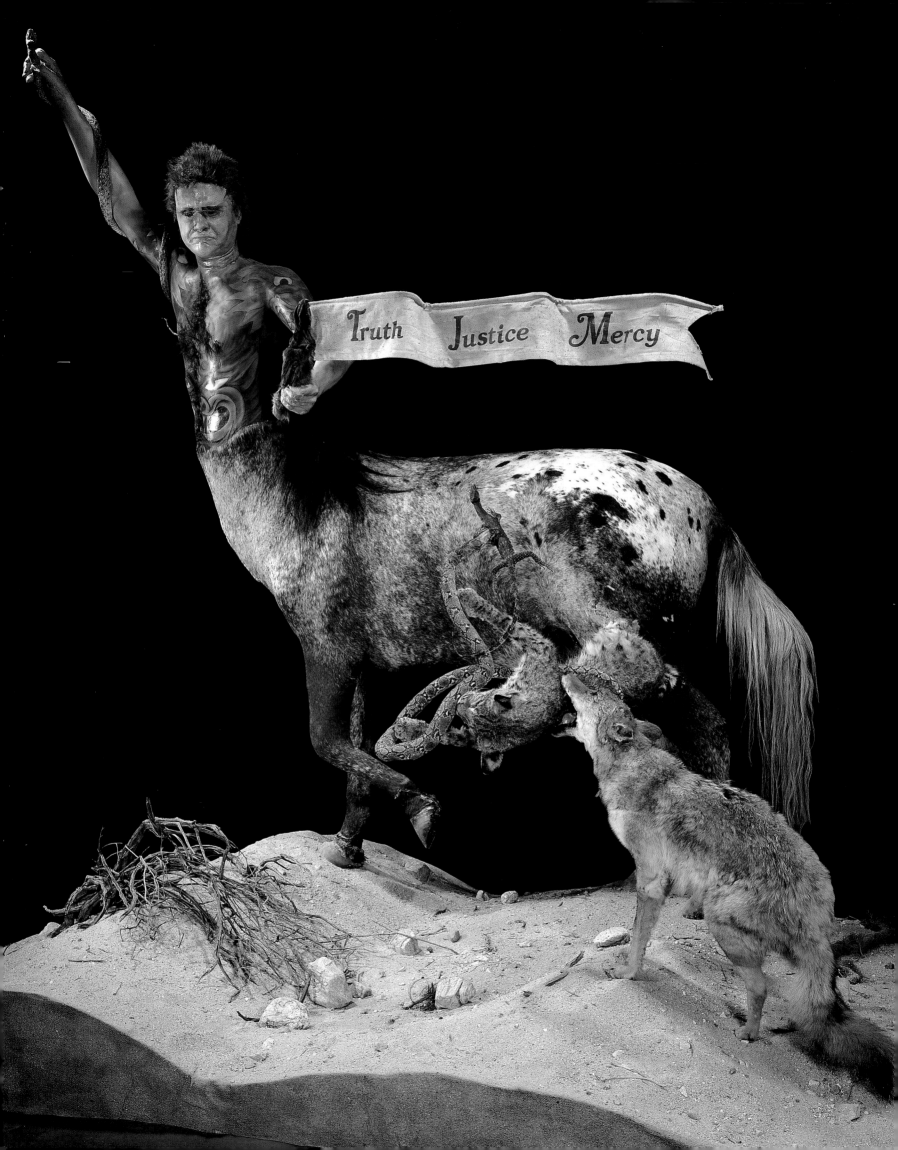

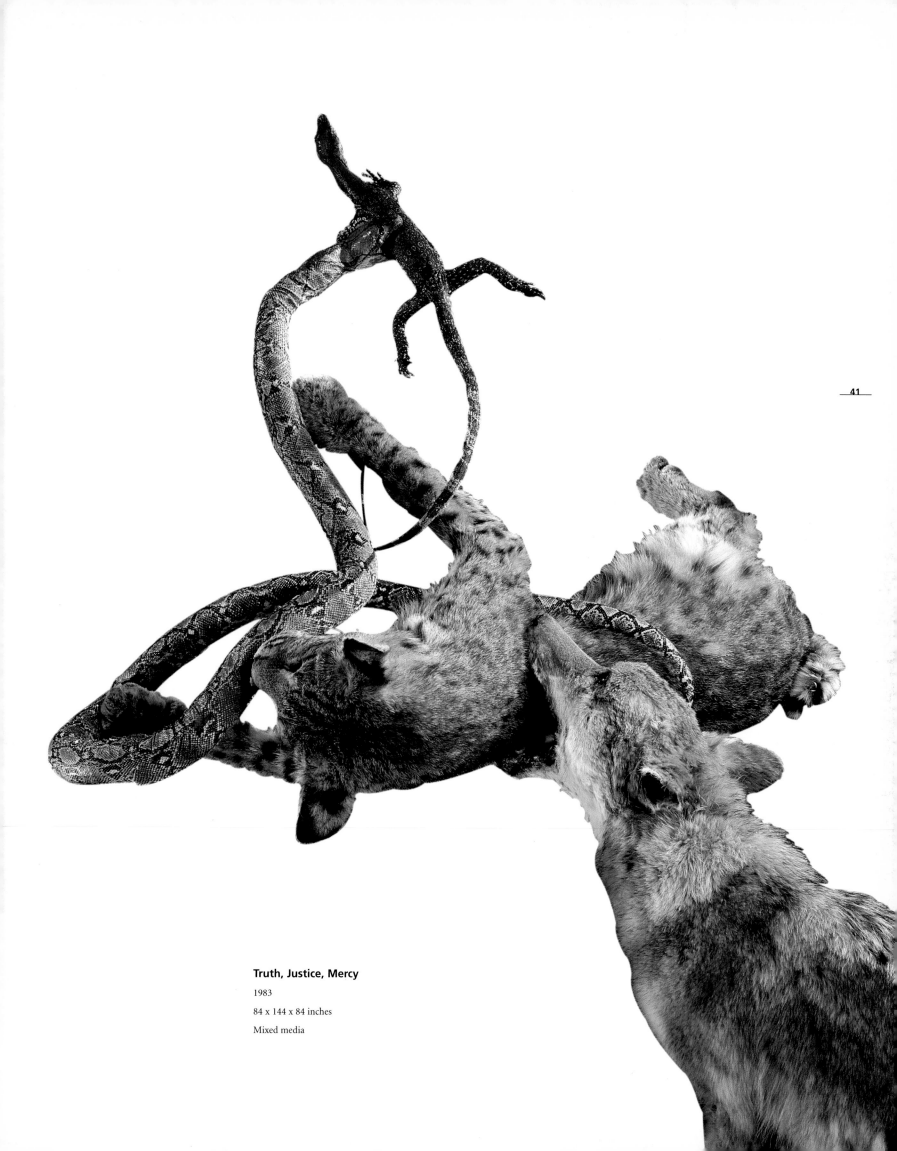

Truth, Justice, Mercy

1983

84 x 144 x 84 inches

Mixed media

Dirt Man
Series

The Dirt
Babies

Dirt Baby

1986

Edition 2/5

14 x 10 x 6 inches

Cast dirt

Collection of Christian Leigh

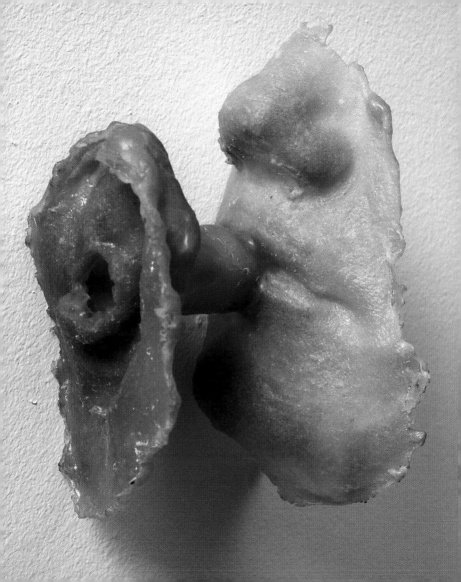

...body found
...ered outside
...ingham home

Michael Grunwald
GLOBE STAFF
d Tom Moroney
E CORRESPONDENT

NGHAM – A John Han...
ive allegedly beat an...
e in their yard late Mo...
iced open her chest wi...
knife, then ripped ...
nd lungs and impa...
8-inch wooden stake...
re encounter soon a...
e slaying, the sus...
rangers he had f...
e that night abo...
asta dish, police ...
H. Rosenthal, 40, ...
officer at Joh...
Insurance, ...
State Hosp...
hiatric eval...
nt at F...
t. A psych...
m said tha...
action to t...
wife as "...

d body –
J. Rose...
er job a...
anager...
for her...
s disco...
SLA...

Kan., Nov. 23 (AP) – A
scaped a fire that de...

Man Is Charged in His Girlfriend's ...

MOUNT HOLLY, N.J., Nov. 25
(AP) — A man fatally stabbed his
estranged girlfriend, telephoned her
mother to say he was going to marry
the corpse and then drove to West
Virginia where he was captured, the
authorities said today.

The man, Forrest D. Fuller, of
Pemberton Township, N.J., was ar-
rested in the Last Stop bar in Fair-
mont, W. Va., on Thursday aft...
told a barmaid that his d...
friend was outside in th...
Sgt. Jack Smith, a spoke...
Burlington County Pros...
fice.

Authorities found the
corpse of his girlfriend, Jodie...
wrapped in blankets in the rea...
of her 1994 Chevrolet Camaro,
Sergeant Smith. A wedding dr...
was in the trunk.

Mr. Fuller, 28, was being held
without bond in the Marion Count...
jail pending extradition to New Jer-
sey, Sheriff Ron Watkins said.

Mr. Fuller strangl...
stabbed Ms. Myers, als...
ton, with a steak knife i...
home some time aft...
Wednesday, the ...
Then Mr. ...
an's m...
said...

Teen-Ager Gets Life In Michigan Slaying

WHITE CLOUD, Mich., M...
(AP) — A teen-ager who ...
friends to a party to see the ...
wrapped body of the dead m...
whom she lived was sentenced t...
in prison today for his murder...

Devon Watts, a 17-year-old ...
history of bad relationships wi...
er men, had been living with L...
ughey, 73, in his trailer a...
north of Grand Rapid...
tts said she was ...
last Octobe...
that the ...

Islamic Dress Code D...

ANKARA, Turkey, Aug.
ters) — A Turkish mot...
daughter have been shot
male relatives for dressing
estly in the latest violen...
over Islamic dress code ...
the newspaper Milliyet sa...

Emine Deniz, 40, and he...
Hamide, 22, were slain ...
Sea province on Monda...
members of their family ...
ing revealingly," the pap...
In another incident ...

THE NEW YORK TIMES

Man Admits

NEWARK, Dec. 23
year-old Nutley mar...
today to killing his ...
hatchet, and his conf...
ed an accomplice to ...
was then arrested, ...

The man, Matth...
pleaded guilty to m...
to commit murder D...
session of a weapo...
in the June 20, 1993,
D'Angelo, Essex C...
Clifford ...

Ms. ...
base...
Man...

Teen-Ager Is Sentenced in Mother's Killing

STEUBENVILLE, Ohio, Oct. 3
(AP) — A 16-year-old convicted of
killing his mother by shooting her in
the head with arrows was sentenced
on Monday to 15 years to life in
prison.

The youth, Brian Nemeth, was
convicted on Saturday of murdering
Suzanne Nemeth, 40, on Jan. 7, while
she slept on a couch in their home in
Wintersville, a village just east of
Steubenville in eastern Ohio. She
died eight days later. The authorities
said he shot five arrows into her
head and neck.

Mr. Nemeth, who was tried as ...

adult, was acquitted of the more
serious charge of aggravated mur-
der. He had admitted killing his
mother but said he did not recall ...
actions "after I let the strin...
referring to the first arrow...

His lawyer, Adrian ...
he would appeal th...

Prosecutors ...
come home ...
the killi...
had ...

contended that Mrs.
been an alcoholic and ...
mother.

Principal in Hit Man Case Faces New Count

LEBANON, Ohio, Jan. 5 (AP) — A
high school principal who was
charged three weeks ago with trying
to hire a man to kill his former wife
been accused of sexually ...

...ence Wilkinson, ...
...on 17 felony ...
...stepson. ...

out a motive for the fir...
's a domestic situation ...
are I'm going to l...

ES NATI...

was a
first-deg...
Heemstr...
-degree r...
enced on March...

eth had
ght before
d his mother

That Killed 2...

Police...
In Beat...

A 13-year-old ...
pitalized in critic...
day after his pare...
their friends to d...
beating him with a ...
police said.

The boy, who was ...
suffered injuries to the ...
and body, and was be...
Beth Israel Medical Cente...
officials said.

Police officers found the ...
home of Jerry Hicks at th...
bors called 911 and ...
7 P.M. Wednesday ...
a child scream ...
arrested, ...

as Doctor...

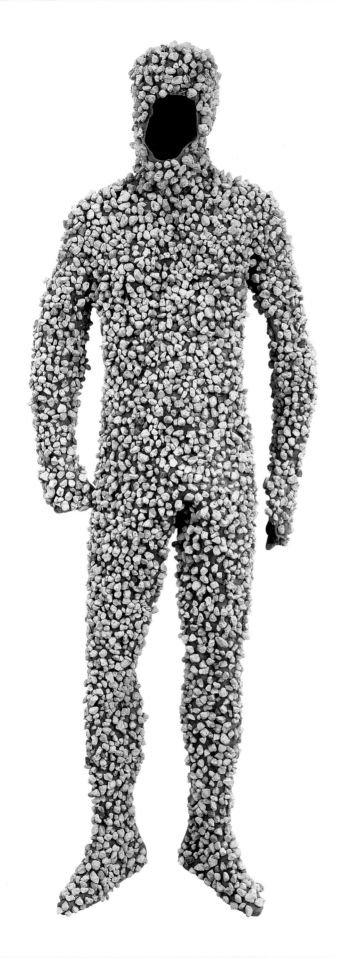

Interpersonal Relationship Suit

1995

74 x 26 x 12 inches

Latex rubber, stone

Collection of Paul van der Spek

Cradle Camouflage

1995

16 x 30 x 15 inches

Latex rubber

Collection of the artist

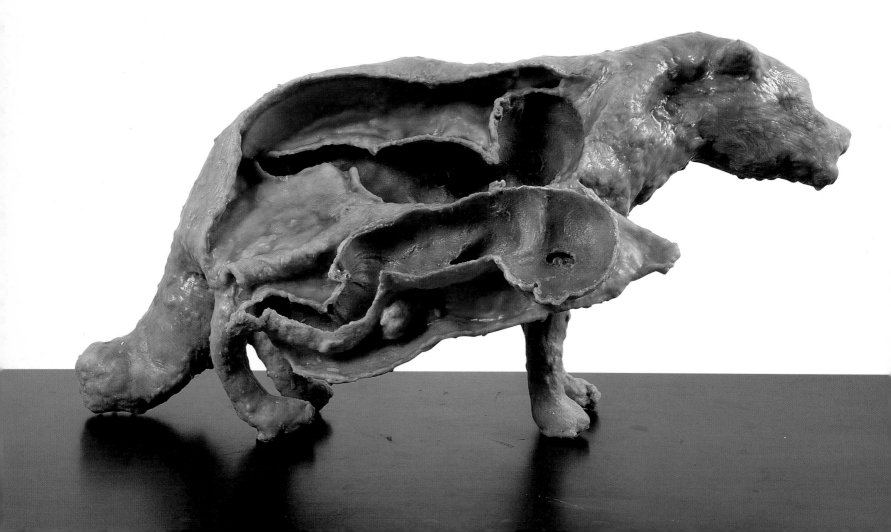

Jury Convicts Man in Baby's Bowling Ball De[ath]

JERSEY CITY, March 3 (AP) — A Jersey City man was found guilty today of manslaughter for throwing a 16-pound bowling ball off an overpass, killing an 8-month-old girl who was riding in her family's car.

A Superior Court jury deliberated about 7 hours over 2 days before convicting the man, Calvin Settle, 19, of reckless manslaughter, opting against the [...]

weapons offense. He will be sentenced on April 7 and could face up to 10 years in prison.

Mr. Settle testified that the ball ha[d slip]ped out of his hands as he sto[od ...] [h]ighway overpass or [...]

truck heading westbound an[d ...] its bumper before crossing th[...] er. It smashed through th[e] shield of Santos and Donna [...] 1991 Audi, hitting the baby, [...] Rivera, who was riding in a [...] in the back of the car. S[...] several hours later.

[...] family, of Brooklyn, w[...] [...]est of Routes [...]

Convicted of Killing Girls to End Support

MONROEVILLE, Ala., Aug. 2 (AP) — A jury on Tuesday convicted a man of murdering his 14-month-ol[d] twin daughters, who were asphyxi[at]ed by fumes one day after a[n $] [c]hild-support payment was dedu[...] [...] paycheck.

[...]d the ma[n] [...] a possibl[...] [...]ting ch[...] [...]e could f[...] [...]encing,[...] [...]ly de[...] [...]e twin[...] [...], sayin[...] [...]al.

Man Held in Beating of Handicapp[ed]

SHELBY, N.C., Sept. 30 (AP) — The father of an 11-year-old boy who has muscular dystrophy paid three teen-agers' $5 to beat him, an effort [to] make him tougher and teach him [...]

had muscular dystrophy [...] that causes a progressive [...] the muscles.

Mr. Nevel, who watched [...] and urged his son to fight [...] the teen-agers to "do what[...] want to with him, but don't k[...] a police report said.

In an interview shown on a [...] lotte television station, WBT[...] Nevel, now being held on $60,00[...] said: "I told them to come in wr[...] with him — play with him. But [...] not say beat him up."

Tony told the police that his [...] [att]ackers had hit him in the face, [...] [...] ears, kick[...] [...] repeated[...] [...]authoritie[...] [...] to charge [...]

Girl Badly Burned in Oven

COLUMBUS, Ohio, Oct. 28 (AP) — A 2-year-old girl is hospitalized with second-degree burns on her back, arms and hands, and her mother has been charged with placing her in a school cafeteria oven set [...] [de]grees.

The woman, Veronica R[...] is being held on $250,000 [...] county jail. She was arra[igned] Thursday on charges of [...] assault and endangering th[e] of her child, Channie, who i[s] condition at Children's Hos[...]

The authorities said Ms. [...] walked into the Second Ave[...] mentary School with Cha[...] Wednesday and placed he[r in the] cafeteria oven. School e[mployees] quickly removed the girl an[d called] the police.

A Baby's Stun-Gun Death

PEORIA, Ill., Nov. 24 (AP) — A woman was charged on Wednesday with killing her 7-month-old nephew with an electric stun gun in an effort to stop his crying. The accused, Francine Knox, 37, who was also the foster mother of the baby, Brandon Jordan, repeatedly used the stun gun "to silence the child" as he cried through the night, the authorities said. Stun gu[ns] [...] with [...] [...]weapons [...] [...]ongs that [...] [...]0,000-volt [...] [...]olice de[...] [...]able vi[...]

Father Is Accused [of] Gluing Eyes Shut

[DET]ROIT, Aug. 19 (AP) — A fa[ther ha]s been charged with sealing [a slee]ping 5-year-old daughter's [eyes sh]ut with Super Glue after [a fight] with the girl's mother over [...]

[Fath]er, Gene Jamison, 33, was [charged] with child abuse, felonious [...] [an]d assault and battery, Of[ficer] Dahm said.

[...]e said Mr. Jamison ap[...] [...]ue to the eve[...] [...]sia Jamison[...] [...]off her pon[...] [...]his wife be[...] [...]him money.[...] [...]charged fro[...] [...]night after e[...] [...]was expected[...] [...] several day[...] [...]ely sealed h[...] [...]sed her righ[...] [...] party, a pedi[...] [...] manent dam[...] [...], and the ab[...]

Pathologist Says 5 Children Die[d of De]liberate Suffocation

[...]fully de[...] [...]e h[...] [...]pumping c[...] [...]exhaust pipe or i[...] [...]seat, where the twins [...] [...]or by altering a gas heater [...] [...]avoid[...] [...]000 in[...]

[...] Of Abus[e]

Two New York City [...] [wh]o live together were [...] [...]yesterday and char[ged] [...]angering the welfare o[f] [...] the 23-month-old daug[hter] [...] the officers was foun[d] [...]en physically abused. [...] When the officers brought [...] the Mary Immaculate Hos[pital] [...]eens Sunday night with [...] [...] thumb, a doctor determine[d] [...] she had also been beate[n] [...] had a three-[...] [...]ture on her righ[t] [...] skull fractu[re] [...] buttocks, had [...] [...] jaw a[...]

Death Trial

Abused Girl [...]

Ro[...]

Nov. [...] [...]tried to sell their [...] [...]ters to another cou[...] [...]ear the police [...]

Trash Suit

1995

14 x 72 x 40 inches

Latex rubber, trash

Collection of the artist

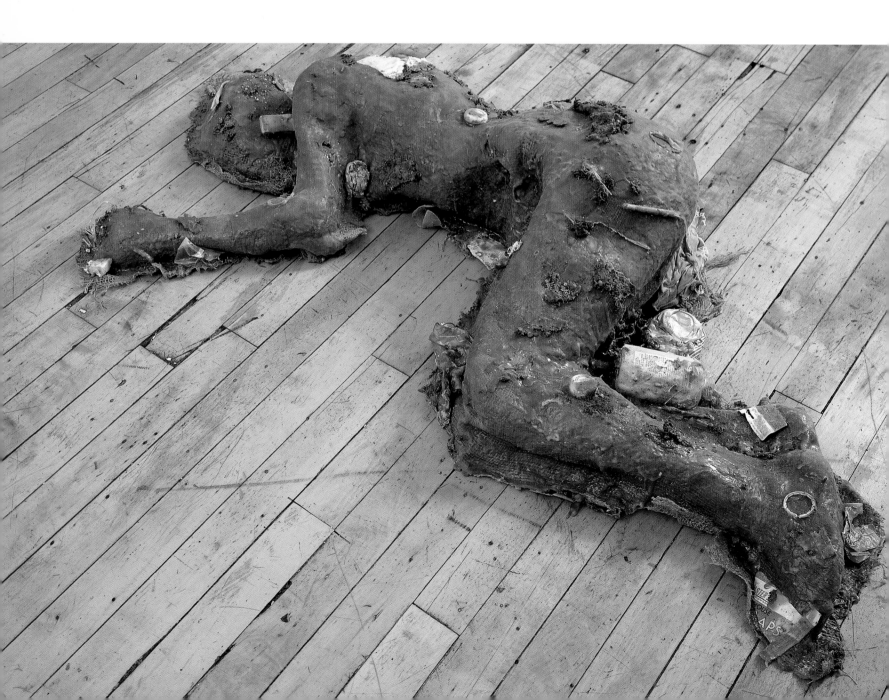

Shell

1995

38 x 65 x 30 inches

Latex rubber, foam

Collection of the artist

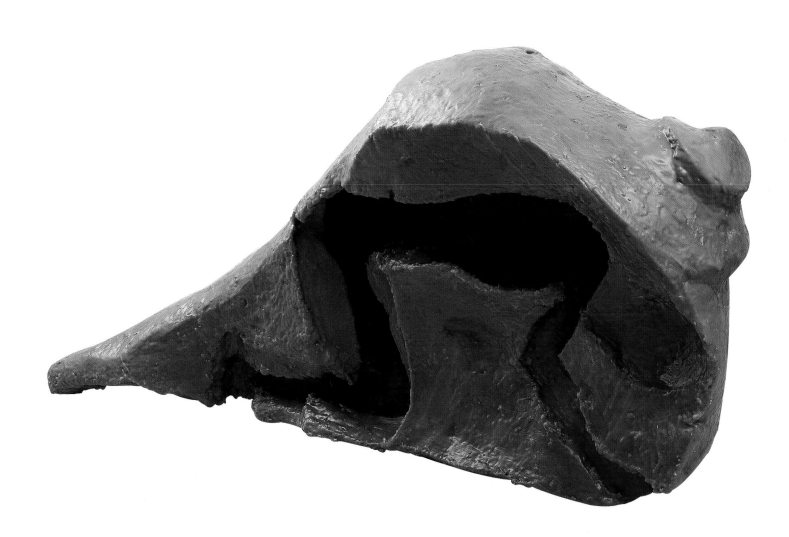

eadly Virus is Identified in Outbreak in Z

By LAWRENCE K. ALTMAN

Scientists have found preliminary
vidence that the Ebola virus, one of
he deadliest infectious agents
nown, is the cause of a mysterious
sease that has broken out in Zaire,
World Health Organi-
enters
ention

diseases in developed countries. A
major reason for the spread in poor-
er countries appears to be that hospi-
tals often lack adequate supplies of
needles and syringes, making their
reuse necessary. In addition, doctors
and nurses may not always obey two
cardinal principles of medicine:
washing their hands and using anti-
septic techniques, because clean wa-
ter is not always available.

Federal and international health
risk of the spread of
from

airports to check for
among travelers fron

Health officials als
doctors to consider t
a hemorrhagic fever
who has fever and bl
James M. Hughes, an
Centers for Disease

The new Ebola ou
tered in the city of K
east of Kinshasa, Zai

One of the principa
of scientists entering
to calm panic, said D
W.H.O. Information
hed hospital

Death of a Rancher in Texas Is Attributed to 'Killer Bees'

HARLINGEN, Tex., July 19 (AP) —
Federal agricultural officials say the
honeybees that killed an 82-year-old
rancher last week were the Africanized
variety known as killer bees.

"Our lab has confirmed that the bees
are Africanized," said Kim Kaplan, a
spokeswoman for the Federal Depart-
ment of Agriculture in Greenbelt, Md.
Final autopsy results are not yet avail-
able, but the pathologist who did the
autopsy listed the preliminary cause of
death as acute fluid buildup in the
lungs caused by insect stings.

If the cause of death is confirmed,
the rancher, Lino Lopez, would be the
first person killed Africanized bees
in the United Stat
sive variety mig
1990. Harlingen,
from the Mexica

Virus Imperils Texas Sh

Mysterious Disease From Ecuador Is Mo

By SAM HOWE VERHOVEK

OS FRESNOS, Tex., June 8 —
th Gregg, the manager of Harlin-
Shrimp Farms, first knew that
ething was wrong one day last
th when he saw a flock of sea
hovering and diving over one of
rimp ponds here on the Laguna
e of South Texas. The gulls
relishing an uncommon feast:
shrimp.
is thing spread like a forest
Mr. Gregg said, shaking his

Last December, Yale Uni-
versity lost the two chief re-
searchers at its Arbovirus Re-
search Unit to the University
of Texas Medical Branch
Center for Tropical Diseases
in Galveston. They wanted to
take their work with them,

dengue fever and encephali-
tis. Earlier in the year, the
Yale lab had been the site of a
near-fatal spill of Sabia virus,
for which a visiting research-
er was disciplined.
Moving the
meant

Virus by Fedex

How do you ship several
thousand strains of danger-
ous viruses 1,700 miles from
one sterile lab to another?
Fedex.

SMILES: Ti

sp
dre
bug
S
virus
wher
ma in
For
erratic
tal Uni
has hit
ica but
shown u
cific Coa

tainers and
side 61 fu
drums plast
zard warning
Total

Europe Orders Ban on Exports Of British Beef

By JOHN DARNTON

LONDON, March 27
fears that a

NATIONAL FRIDAY, APRIL 12

W

Says

al Virus Are Edg

AN

Dr. Joel Williams, a m
miologist at the center
noses were made
from tissue or serum
Researchers are

pt. 25 (Reu-
h officials
the spread
killed at
ore than
rn coast.
ovincial

hant
highly
lway
ed c

Nearly 3,000 Are De In Epidemics in N

GENEVA,
Almost 3,00
childre
me

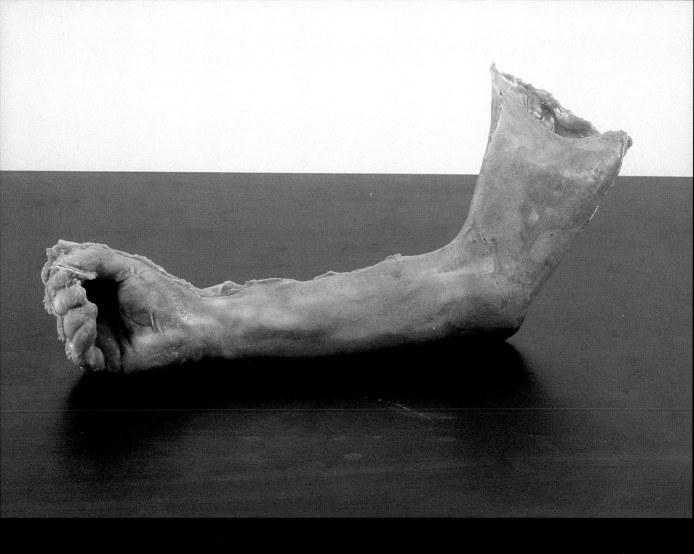

Arm Protector

1995

14 x 22 x 6 inches

Latex rubber

Collection of the artist

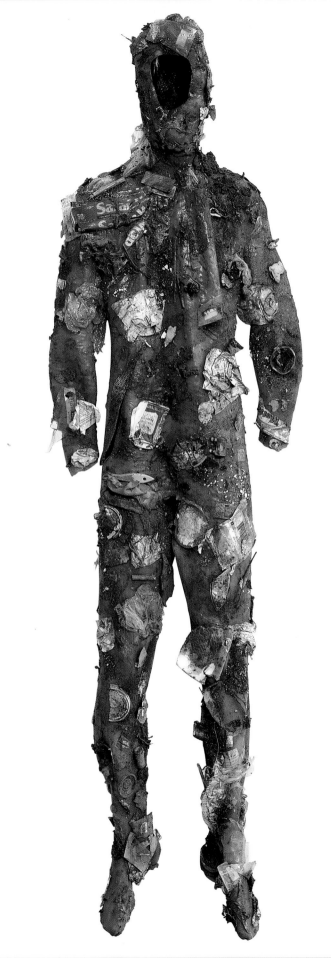

Trash Suit

1995

76 x 24 x 12 inches

Latex rubber, trash

Collection of the artist

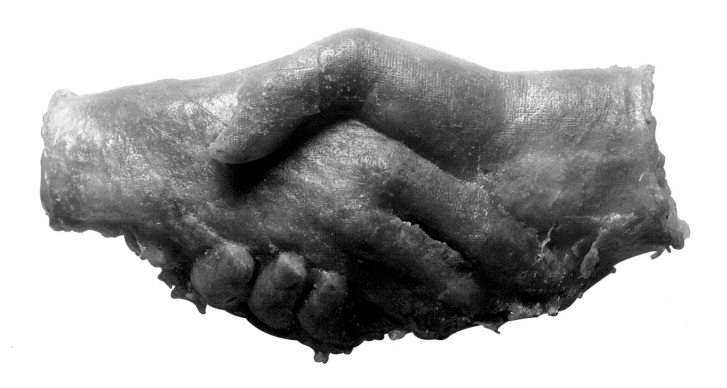

Handshake Condom

1995

6 x 10 x 4 inches

Latex rubber

Collection of the artist

Child Skin

1995

37 x 22 x 12 inches

Latex rubber, dirt

West Family collection

at SEI Investments

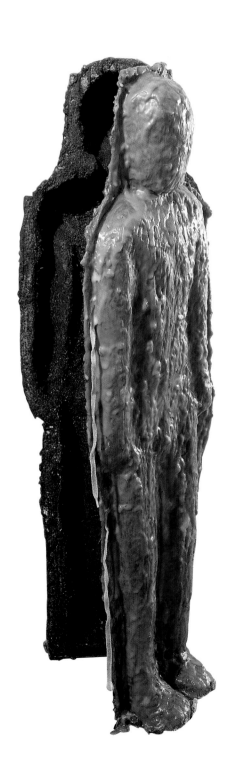

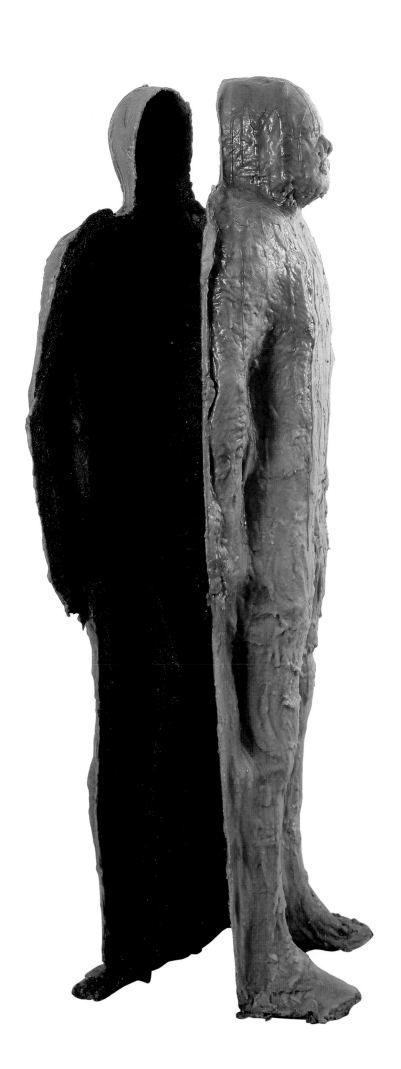

Decentered Skin

1995

75 x 36 x 30 inches

Latex rubber, dirt

Private collection

The
Windows

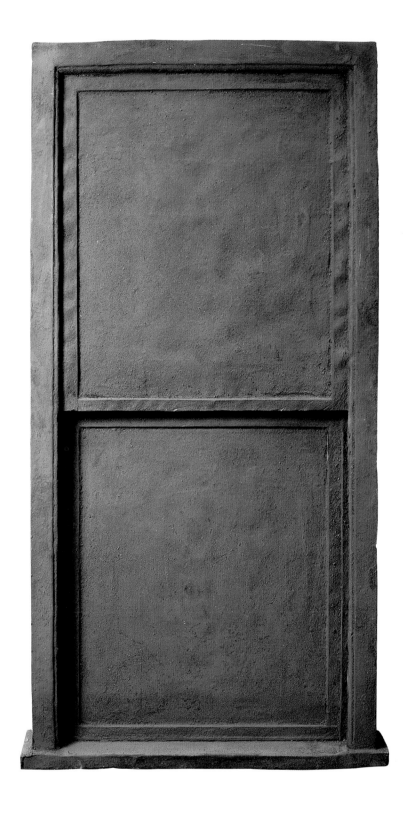

Window Series #1

1991

70 x 35 x 7 inches

Cast dirt

Collection of Hélène de Franchis

Window Series #2

1991

57 x 41 x 4 inches

Cast dirt

Collection of the artist

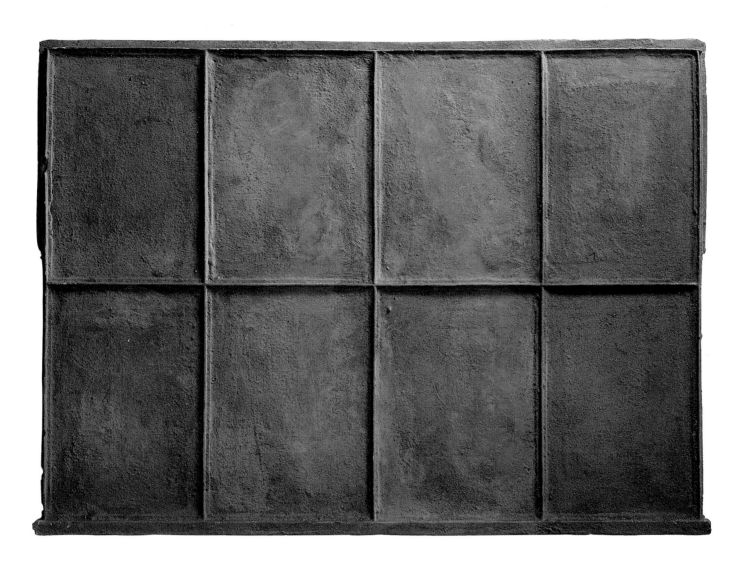

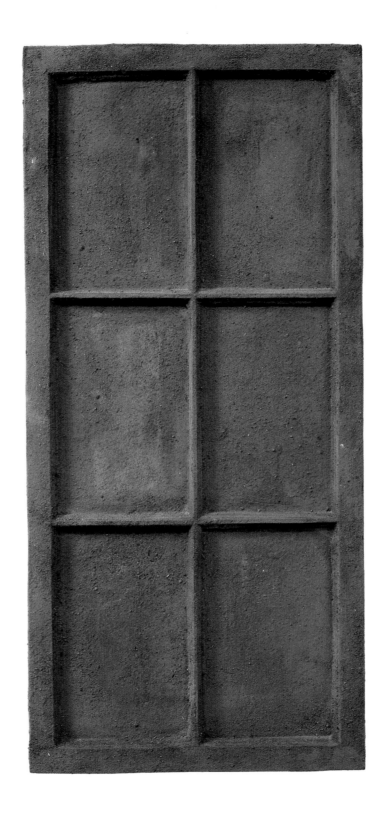

Window Series #6

1991

40 x 15 x 2 inches

Cast dirt

Collection of Hélène de Franchis

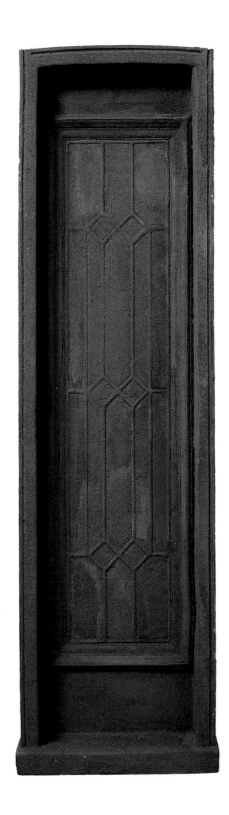

Window Series #7

1991

52 x 13 x 6 inches

Cast dirt

Private collection

Window Series #8

1991

64 x 28 x 4 inches

Cast dirt

Collection of the artist

Chair

1989

36 x 22 x 22 inches

Wood

Later destroyed

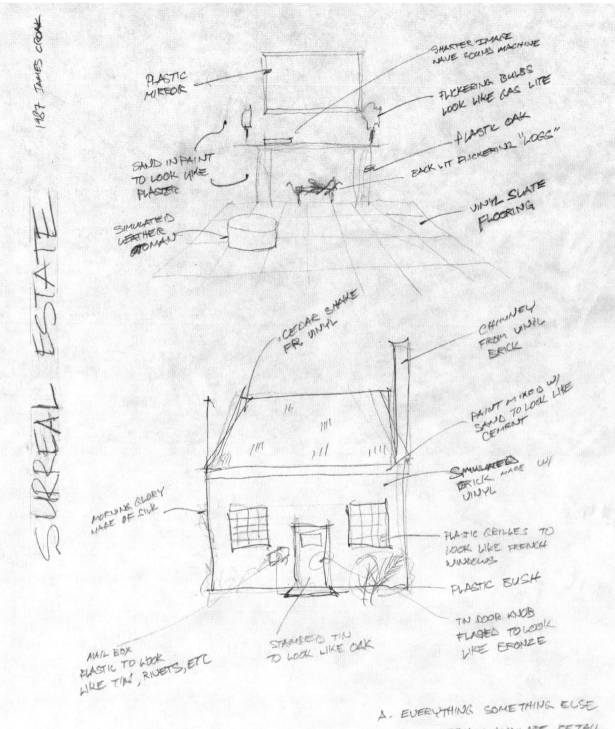

SURREAL ESTATE

1987 JAMES CROAK

PLASTIC MIRROR

SHATTER IMAGE WAVE SOUND MACHINE

FLICKERING BULBS LOOK LIKE GAS LITE

PLASTIC OAK

BACK LIT FLICKERING "LOGS"

SAND IN PAINT TO LOOK LIKE PLASTER

VINYL SLATE FLOORING

SIMULATED LEATHER OTTOMAN

"CEDAR SHAKE" FR. VINYL

CHIMNEY FROM VINYL BRICK

PAINT MIXED W/ SAND TO LOOK LIKE CEMENT

SIMULATED BRICK MADE W/ VINYL

MORNING GLORY MADE OF SILK

PLASTIC GRILLES TO LOOK LIKE FRENCH WINDOWS

PLASTIC BUSH

TIN DOOR KNOB FLASHED TO LOOK LIKE BRONZE

MAIL BOX PLASTIC TO LOOK LIKE TIN, RIVETS, ETC

STAMPED TIN TO LOOK LIKE OAK

A. EVERYTHING SOMETHING ELSE
B. ALL MATERIALS AVAILABLE RETAIL
C. ALL MATERIALS MAILED TO SITE
D. PASS LOCAL BLDG. CODE

Surreal Estate

1988

12 x 20 x 15 feet

Cast dirt

Temporary installation commissioned

by the Aspen Design Conference

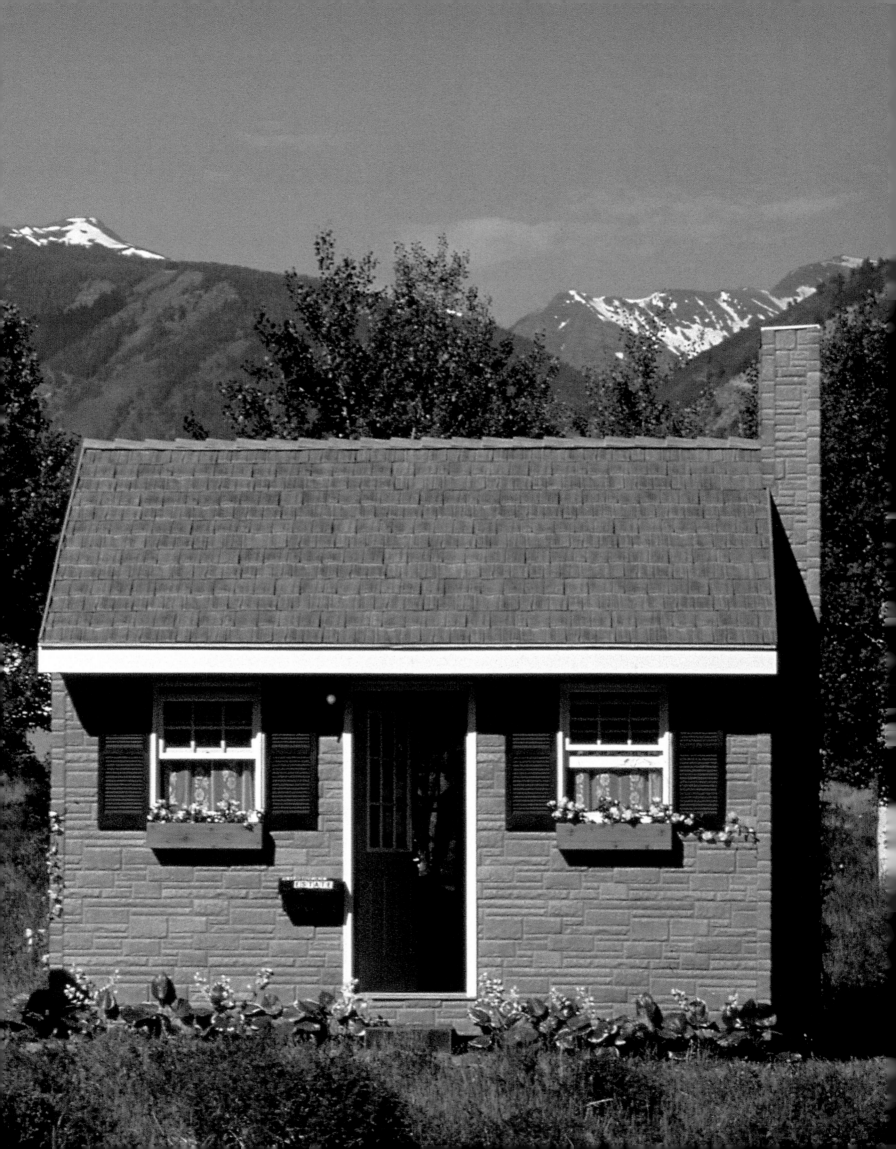

Iron

1990

14 x 24 x 8 inches

Cast tar, wood

Umbrellas

1993

28 x 40 x 36 inches

Cast tar

 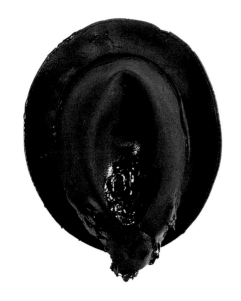 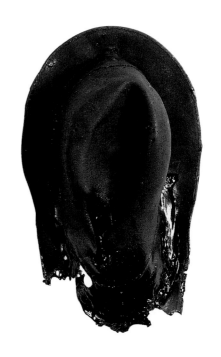

Sequential Hats

1988

15 x 84 x 7 inches

Cast tar

Collection of the artist

Disasters
of War

James Croak was born in Cleveland, Ohio, in 1951. At age eleven, he and his family moved to Louisiana where he became interested in the classical guitar, his first artistic endeavor. Croak proved to be a musical prodigy, studying with Andres Segovia at the age of fifteen. The following year he gave a series of concerts in Mexico City as part of the 1968 Olympic Summer Games. Croak then spent five years at the Ecumenical Institute in Chicago, concurrently studying sculpture at the University of Illinois, where he graduated in 1974.

Once in Chicago, like many of his peers, Croak initially worked with massive, abstract, metal sculpture. After receiving an artist-in-residence grant from the National Endowment for the Arts in 1976, Croak worked in Wichita, Kansas, speaking to the public about issues concerning contemporary art. During this period, he learned specialized techniques for fabricating with aluminum by visiting local airplane factories. From 1970 to 1978 Croak made over seventy aluminum works painted in bright, neon-type colors with titles such as *Modern Emotion*, 1978, a harbinger of the work to come.

In 1976 Croak moved into an old 14,000-square-foot fire station in downtown Los Angeles. There he quickly abandoned the Chicago-based abstract impulse and returned to figural assemblage work in mixed media, including taxidermed animals and found objects. Croak's California work received a great deal of critical attention, even celebrity. In 1984 he left the West Coast for Brooklyn, New York, where he created his first "dirt" sculpture made with a combination of dirt and binder, a technique that he invented in 1985. Croak began exhibiting widely in group exhibitions in the United States and across Europe. Eventually the artist moved to Manhattan, where he currently resides, and he has continued working with unusual materials such as tar, resin, and dirt. Croak's unique visual language continues to gain critical attention, and his work was recently included in exhibitions in Spain, Italy, The Netherlands, and Germany. The following interview took place over six months in 1997-98.

Interview with the Artist

James Croak
By Timothy Greenfield-Sanders
New York, 1998

Barbara Bloemink Thomas McEvilley originally titled his essay for this book, "Generations of Monsters: The Sculpture of James Croak." Who and what are your personal monsters?

James Croak I either don't have any or I have all of them: it is the world in general. I had a bad start. My mother died when I was only two, and I was passed around relatives for the next three years, typically living in one place during the week and another on the weekends. Hence my sense of the world is that it is a very unstable and scary place. I knew a mathematician who feared that all of his atomic particles would line up and he would fall through the floor.

Similarly, because of my past, I am always falling through the psyches of those in front of me, no matter how rational they wish to appear, and I perceive a seething unknown in them. Kazantzakis had a great line: "Life startles us at first, it seems somewhat beyond the law." I think the monsters are less in my life than when I was younger; ironically, because death seems more imminent. Perhaps this is the reason. In *The Sibyl,* Par Lagerkvis describes the most severe punishment as having to live forever.

Homage to Villa-Lobos
1978
84 x 60 x 60 inches
Aluminum
Collection of the artist

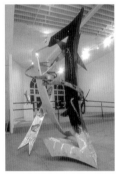

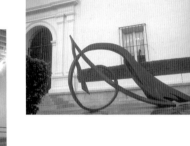

Barrios
1978
60 x 12 x 40 inches
Aluminum
Private collection

Dead Dog
1979
11 x 8 x 8 feet
Aluminum
Collection of the artist

BB Why was your first sculptural impulse abstract, since subsequently your work has been largely figural?

JC I was living in Chicago and the academic program that I was in at the University of Illinois was anti-figurative. I don't mean "non," I mean "ANTI!" Painting was dead and embalmed and the only "authentic" course of action was abstract sculpture. The larger the better, the less reworked the better. Read: Judd, Serra, Rossati. I made work similar to this but simultaneously I had a baroque itch to scratch. I photographed graffiti from the walls of buildings in the area and projected the images onto large sheets of aluminum. Then I fabricated the metal into large-scale sculptures that were essentially three-dimensional graffiti. Frank Stella began making work nearly identical to this around 1974, five years after I initiated my series. Hence I rarely show or discuss my aluminum series; it appears derivative even though I initiated it many years earlier. It's just as well because I think naturally I am a figurative sculptor and this first impulse was beat out of me in school. It was this gestural baroque aluminum work that led me back into figuration.

BB That is a long route to get back to what you wanted to do to begin with. Do you see that this work influenced other artists? Do you see your ideas appearing in the work of others?

JC Many times. A drawing of the *Amarillo Ramp* found in Robert Smithson's effects after he died was drawn on top of the first page of a lecture that I gave while at the Ecumenical Institute titled "Resurgence," describing history as a spiral—an idea outlined in the epic poem *Saviors of God* by Nikos Kazantzakis. This drawing-on-my-lecture turned up in *Artforum* in 1976 in "Site Works" by Lawrence Alloway about earthworks. I was twenty-one when I wrote that.

and the like. These claims are easily dismantled with our present enlightenment but this is recent and some people do not yet understand this. The nature of people is to claim universality...that's a universal statement right there! Tom McEvilley's now famous essay, actually originally only a review, "Doctor, Lawyer, Indian Chief," was the plain language version of these issues that were stewing for many years. His piece was unanswerable, although MOMA tried, and tried,...If that style of working and its symbols, ideas, etc., hold for you, then great. But don't, as do the modernists, claim to have symbols and ideas that hold true from person to person, culture to culture. The test for a structuralist statement is to ask, "Do you believe that would hold true for people you have never met, living in places you have never been?" If the answer is yes, even an unsaid yes, one has tried to make a structural statement. It is a basic human reflex to answer yes, we always answer yes. Where Tom and I had a meeting of minds is that deconstruction is now largely a mannerism. Time to move on. His essay in this book is ground breaking in this area.

What is going to come next is unclear. The modernists tried to control space and failed; now they are trying to control time by saying: We don't have to compare to the majesty of the past, that was then, this is now. Well, I think if you make a good sculpture, it should stand as a good sculpture next to work from any era.

Personally I am falling backwards to a firm footing—everything about dirt seems to be a pun—dirt is solid, firm, common, and incredibly neutral. In my new work, in addition to my interest in Rodin and Michelangelo, I am also looking at the Spanish sculptor Lopez Garcia, who interests me tremendously. I knew nothing of his art until I was sent a book of his work by a collector from Barcelona. Lopez Garcia is one of the most sought-after artists in the world and he is largely unknown in the United States. He is a consummate realist who works with very mundane objects and is extremely adept at illuminating an object or situation or mood.

BB You have made several drawings, using dirt/earth as your medium for drawing on paper. At what point were you making these?

JC I like doing drawings but have not had much time to do them. Two years ago I wanted to continue Goya's *Disasters of War* with twentieth-century imagery. I made about fifteen drawings and edited it down to about four. They will resume at some point.

BB Your most recent work, the full-sized nudes and the body fragments, are again modeled in clay and then cast in dirt. Taken as a whole, there is a sense of your work as having moved from the exuberant, outward, heroic gesture to the more intimate, solitary quiet. Let's discuss your recent work and why its mood is so different from the earlier work.

JC The reversal of mood probably reflects a change of energy as one grows older and more has happened. More blows to the soul. Look at the sinister mood of Chuck Close's recent work compared to the early work from his youth. Same imagery, miles deeper, and darker. I think my work has become more intense as I have aged, although the earlier work seemed more dramatic. Also

I live in New York City now where it is harder to have the space to make the larger heroic scale pieces that characterized the work made in Los Angeles. The dirt work was what I was working towards all the time. It posits solidity in a world that has none. I am currently making a series of hands and full-scale figures using the elaborate nineteenth-century modeling and casting techniques I first used on the Dirt Baby pieces. The Dirt Man series were made differently, and the process resulted in toning down the imagery. With this new work I am continuing my early fascination with skin made from dirt. I believe this area for my aesthetic is barely tapped. Especially I like the hands—as McEvilley pointed out, the whole can look more whole than the whole. It seems to be true.

BB What makes a piece not work for you so that you edit or destroy it?

JC I made a large sculpture of a woman that did not work out. It was a mistake from the beginning, an accumulation of errors. First there was a poorly constructed armature and I used the wrong binder to hold it together, the wrong dirt, just everything—this sometimes happens, not often, but sometimes one ends up with an elephantine mess. The other big mistake I made was in applying the final layer of dirt with a very heavy glue right after it came out of the mold in order to give it texture, and in so doing, I wiped out all the subtleties of the surface. You might not have consciously noticed this if you saw the work, but your eyes would see it. The subtleties of the surface are what make a work seem alive. Otherwise it ends up looking like a dead object, a life cast. If it is a dead object it gets edited.

BB Where do you see your work going in the future? What are your next challenges?

JC Well mainly I want to come up with a sustaining theme of figurative art in this vein in which I am now working. As much dirt work as I have done, it has not really peaked yet. I want to make art that has an uncanny presence.

BB What quote or title would you use to encapsulate your work, or entitle your autobiography?

JC I am fond of an engraving by Goya typically translated as *The Sleep of Reason Breeds Monsters*. Actually an earlier and possibly more accurate translation is *The Dream of Reason Breeds Monsters*. I dream of reason and experience the monstrosities of the world because of it.

De qué sirve una taza?

What Is the Use of a Single Cup

c. 1811

Francisco de Goya

1746-1828

Collection of James Croak

After Rodin

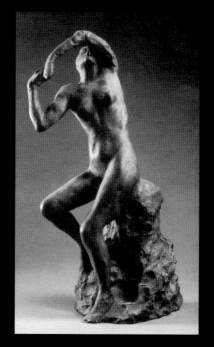

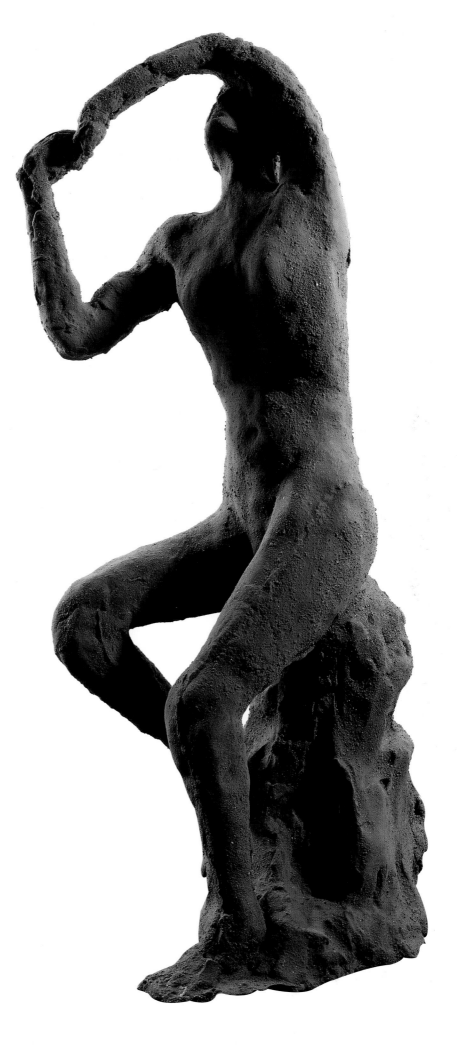

Invocation (after Rodin)

1997

14 x 6 x 7 inches

Cast dirt

Collection of the artist

Untitled (Three Women)

1997

Edition 1/4

14 x 26 x 12 inches

Cast dirt

Private collection of Lola and

Allen A. Goldring

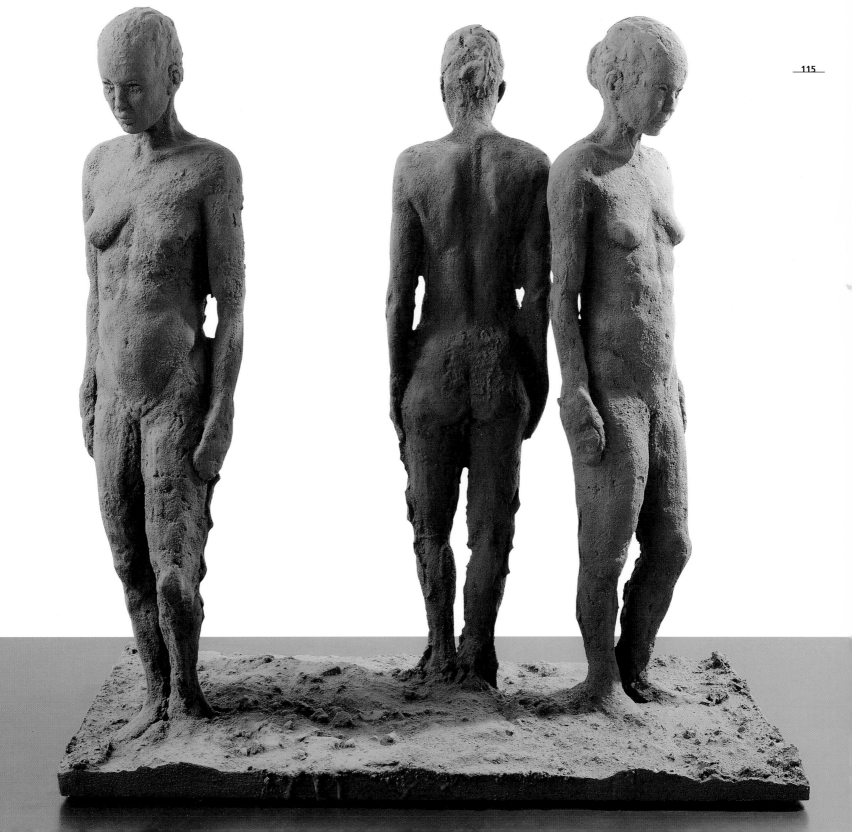

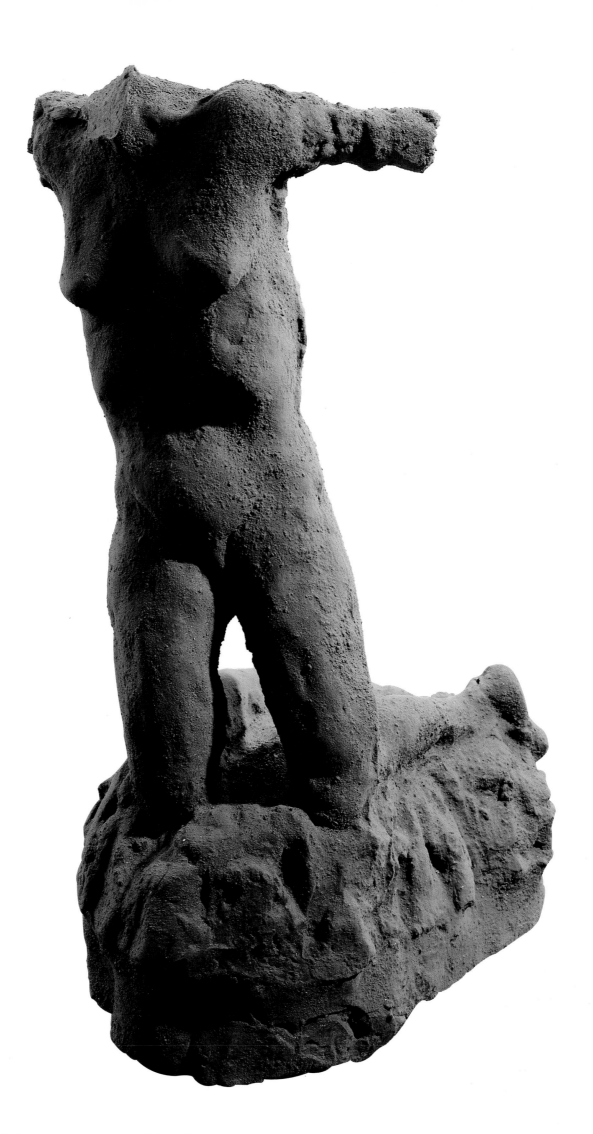

Woman on Rock

1997

12 x 6 x 6 inches

Cast dirt

Collection of the artist

Hand
Series

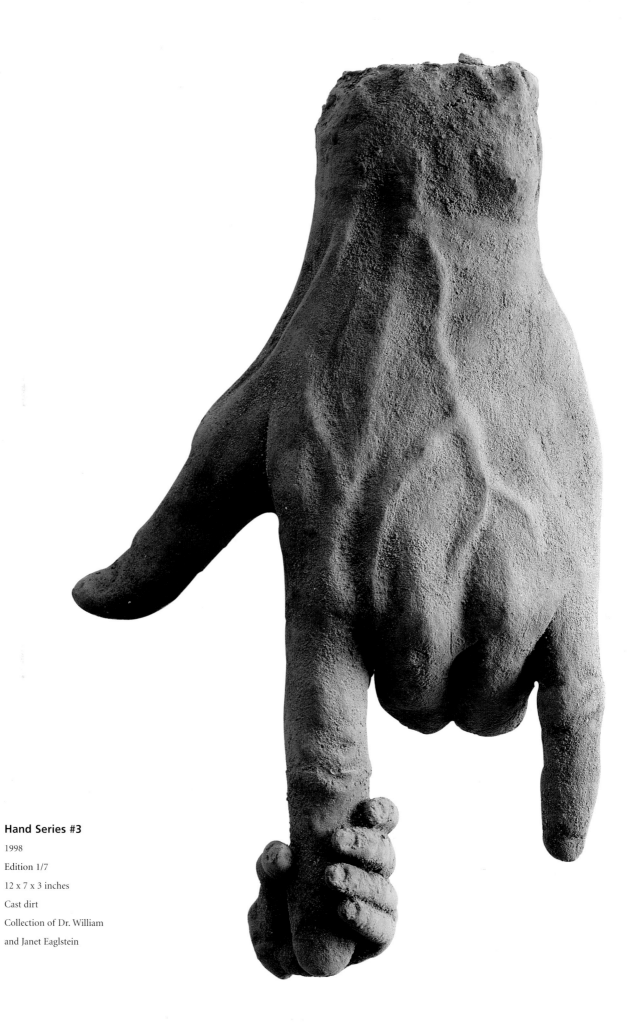

Hand Series #3

1998

Edition 1/7

12 x 7 x 3 inches

Cast dirt

Collection of Dr. William

and Janet Eaglstein

Hand Series #2

1997

Edition 1/7

14 x 29 x 13 inches

Cast dirt

Collection of the artist

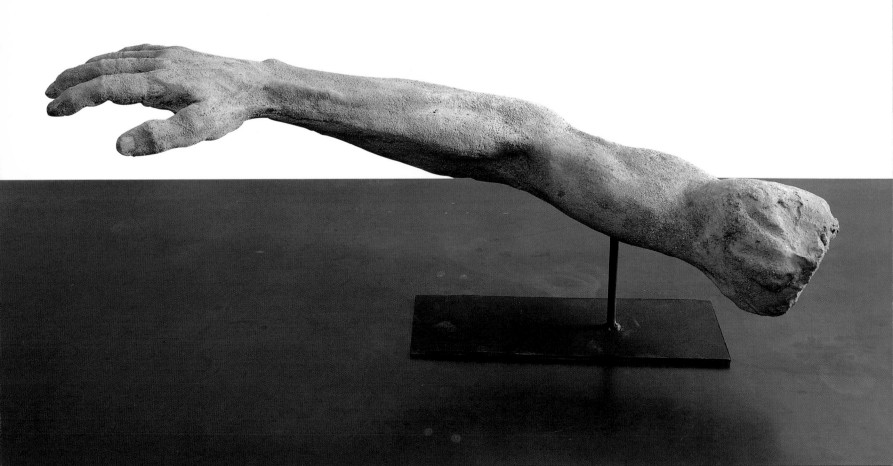

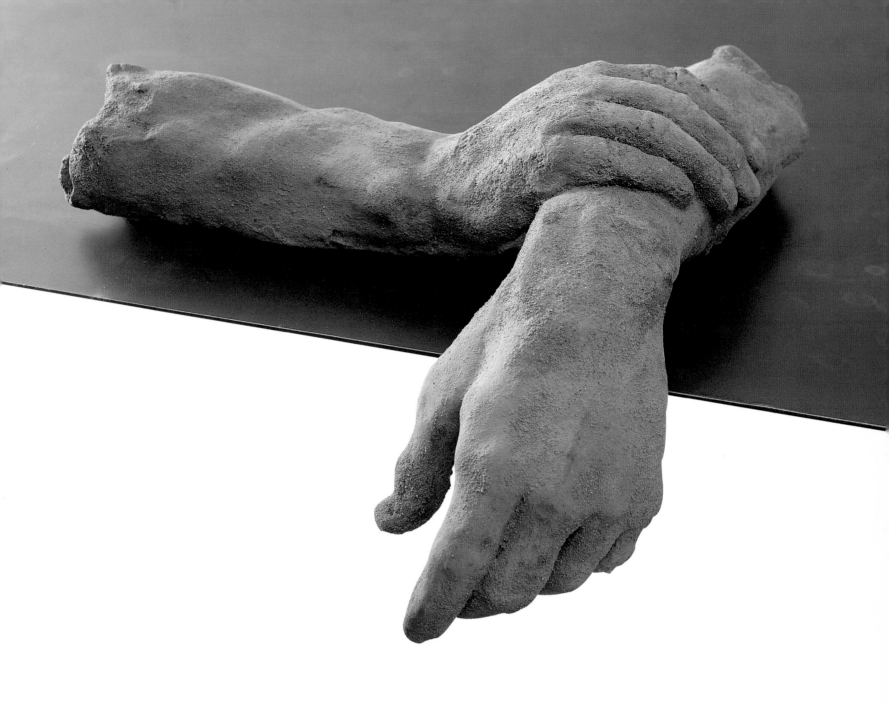

Hand Series #5

1997

Edition 1/7

10 x 12 x 12 inches

Cast dirt

West Family collection

at SEI Investments

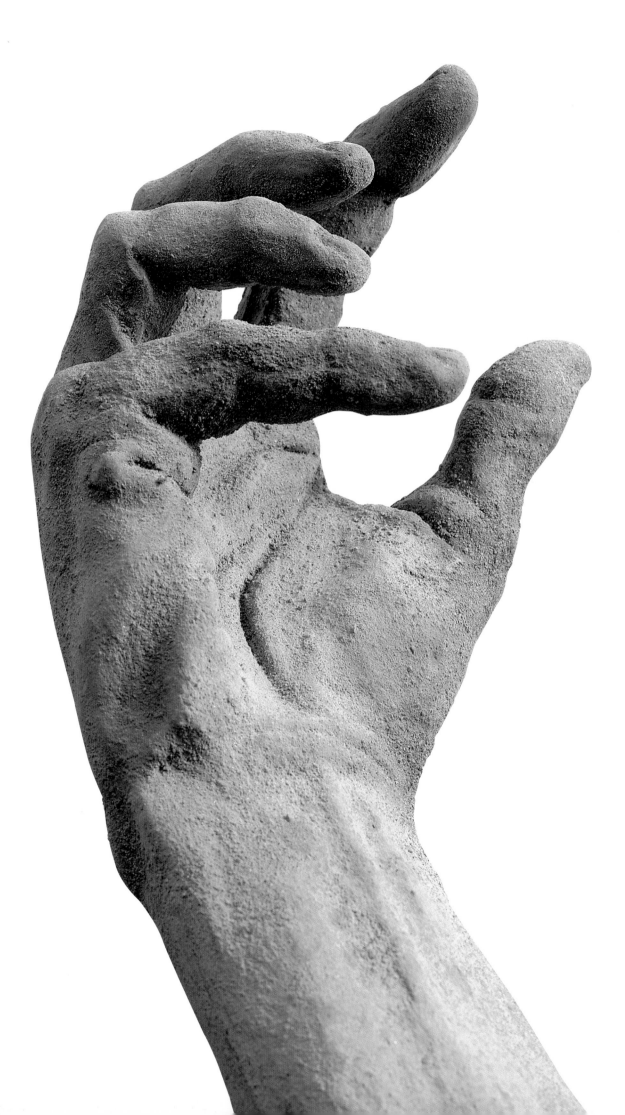

Hand Series #1

1997

Edition 1/9

18 x 29 x 9 inches

Cast dirt

Collection of Barbara J. Bloemink

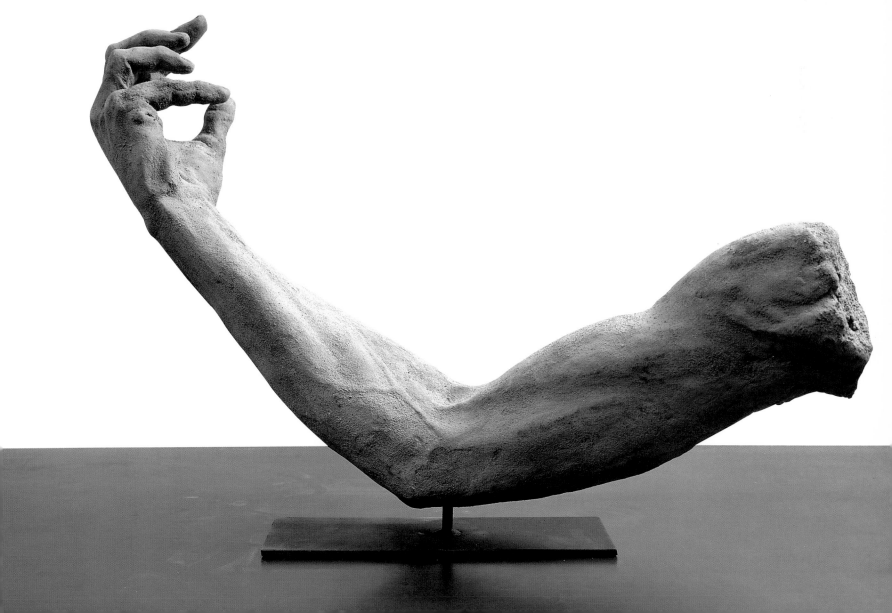

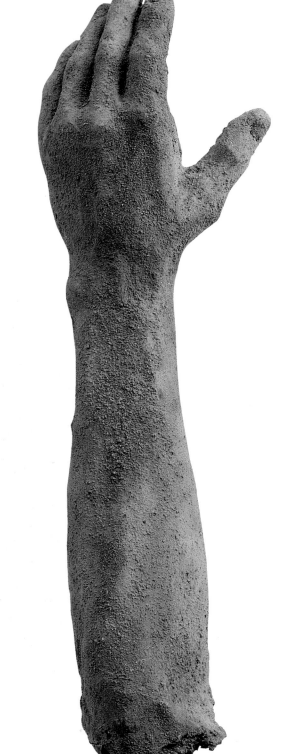

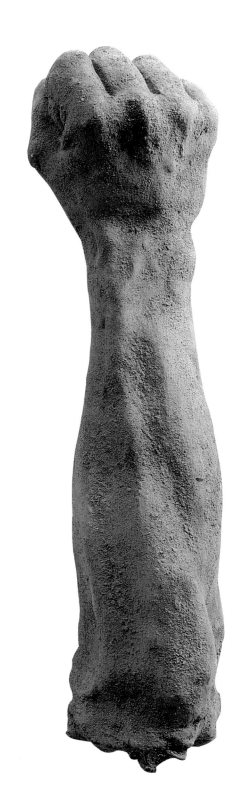

Hand Series #4

1997

Edition 1/7

18 x 17 x 5 inches

Cast dirt

Collection of the artist

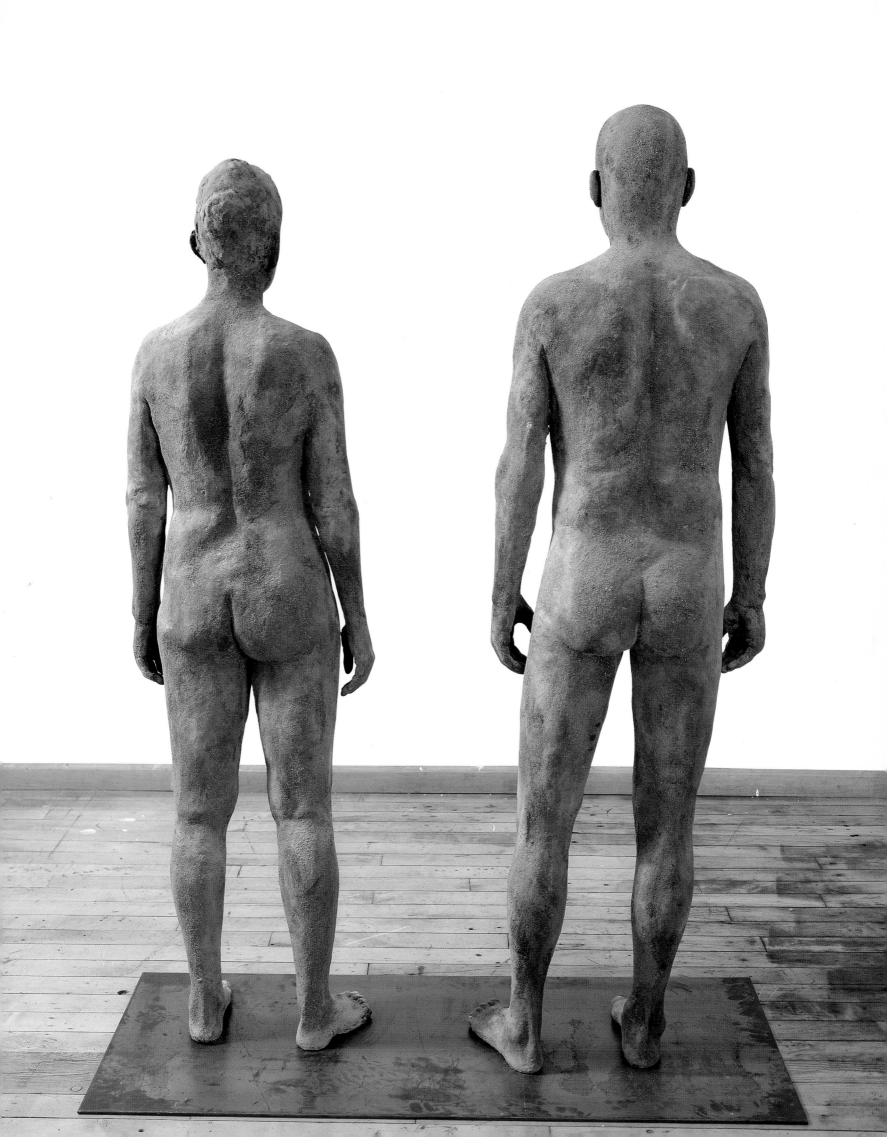

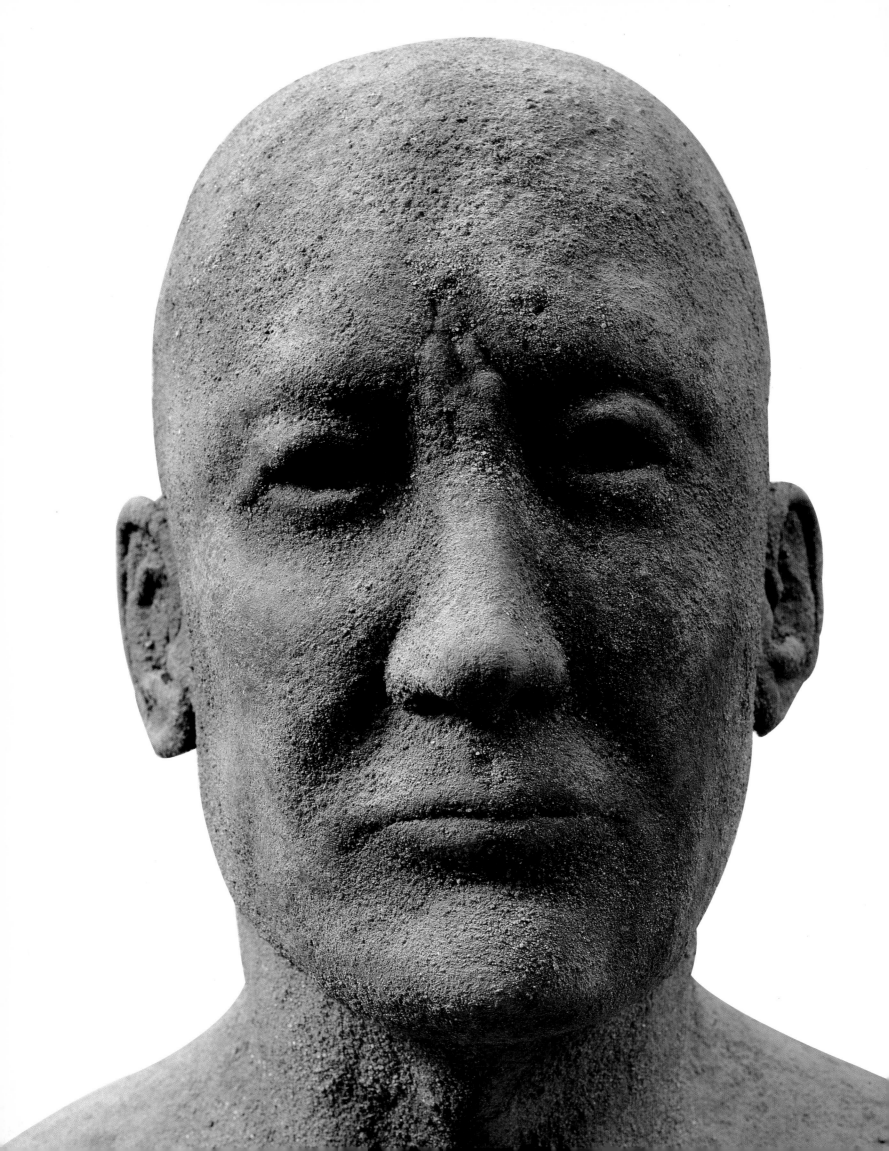

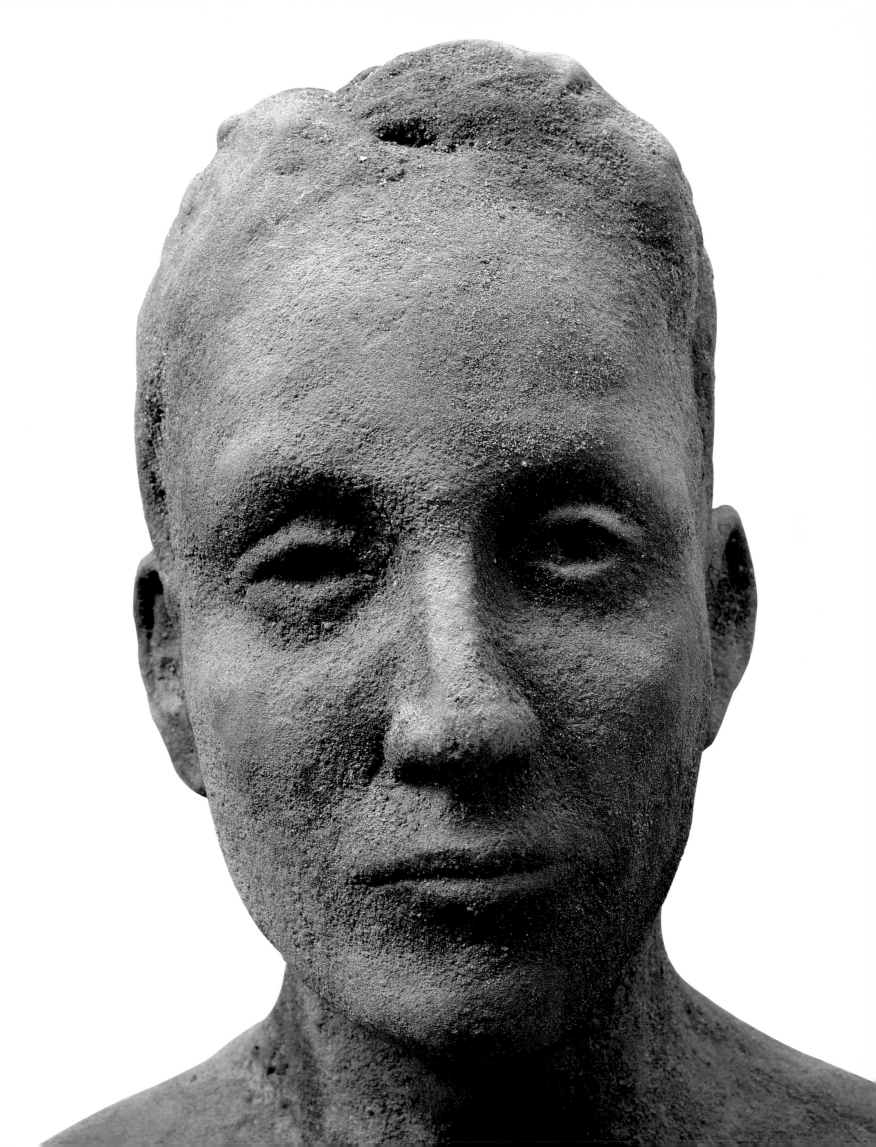

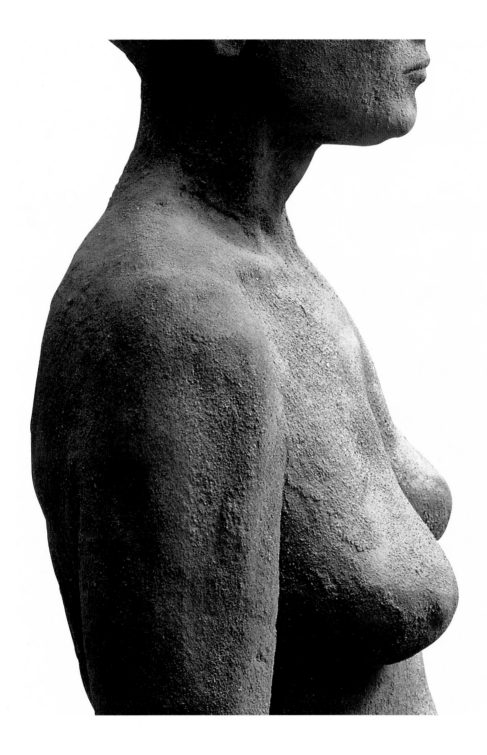

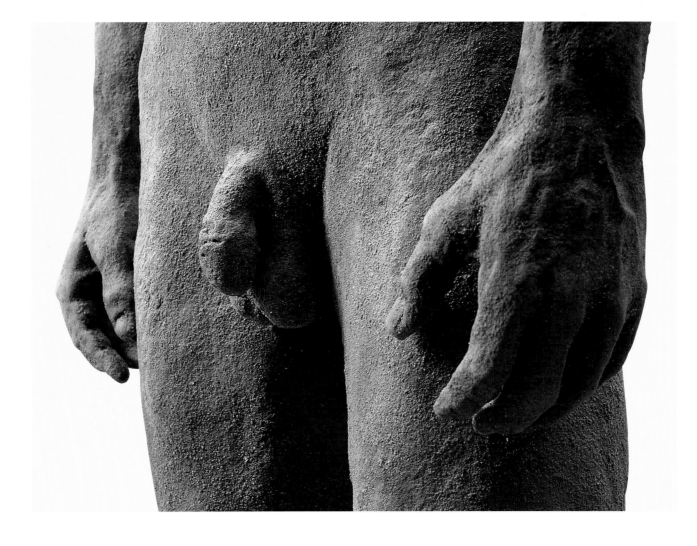

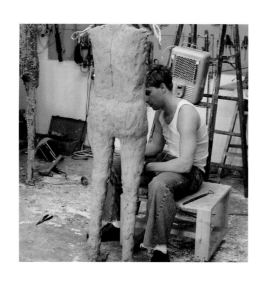

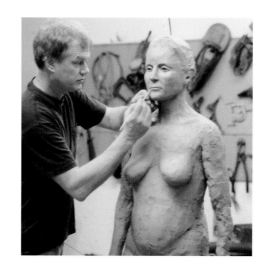

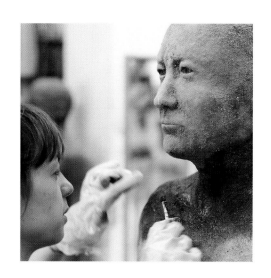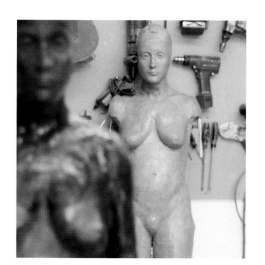

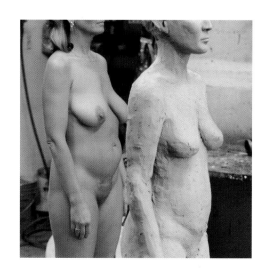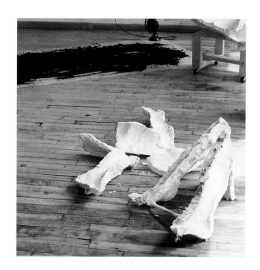

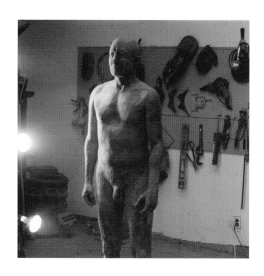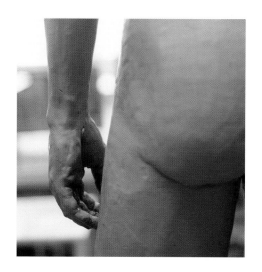

Sea á Child

1997

110 x 115 feet

Bronze pieces over landscape

Proposal for Oklahoma City preschool

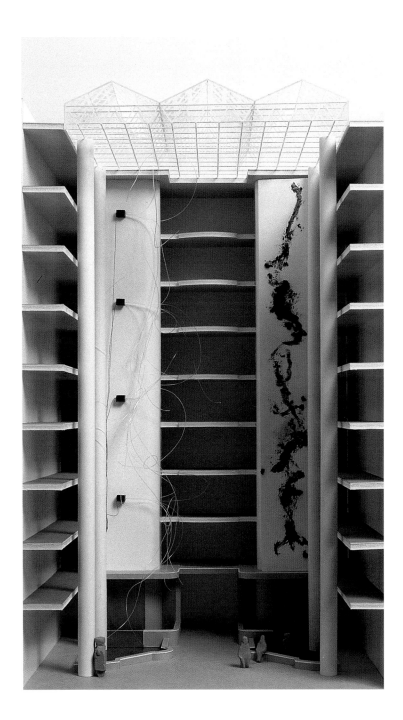

Lighted Earth

1996

92 x 60 x 30 feet

Fiber optic cable, dirt on canvas,

dirt figures

Proposal for The Pierre

Swanke, Hayden & Connell, architects

James Croak: **A Biography**

1951 born to Donald Croak of Iowa and Geraldine Lyons of Ohio. Third of four children. At the age of two mother dies of a medical accident and I am sent to live with grandparents. Three years later my father marries Adele Adams and has one additional child. Raised in the suburbs of Cleveland, Ohio, until 1963 when we move to the outskirts of New Orleans, Louisiana. Showed an unusual knack for building things and was always underway on some project or another.

1965 Became fascinated with jazz guitar heard in the French Quarter of New Orleans and began studying the guitar in earnest. Had a preference for Spanish music and ultimately learned classical guitar. Met maestro Andrés Segovia in 1967 and studied with him briefly.

1968 Performed on the classical guitar at the Summer Olympics in Mexico City as part of the cultural festivities. Gave ten concerts in three weeks, finally got over my stage fright. Was housed with a bluegrass contingent including Doc Watson and jammed during the evening with some of the best musicians anywhere. Saw extreme poverty for the first time in the areas around Mexico City, which had profound effect on me.

1969-74 Finished high school and spent eight months tracing the perimeter of the country on a motorcycle. Saw no way to continue as a guitarist and besides after what I saw in Mexico I thought my energies were better spent on the social movements that were already underway, especially the civil rights and integration movement. Joined the Order of the Ecumenical Institute, a secular-religious order involved in designing and administering social programs. I moved to the Chicago headquarters and did research while studying philosophy and post-war German theology. Became versed in the work of Paul Tillich, Rudolf Bultmann, Dietrich Bonhoeffer, H. Richard Niebuhr, and Martin Heidegger. Especially the "demythologizing" of Bultmann, the precursor to deconstruction. Stayed five years. During this time I registered for sculpture courses at the University of Illinois at Chicago Circle campus, testing out of most academic courses. The program was an antifigurative program—as were most art programs at that time—designed to turn out students who could build large-scale formalist sculpture. Tony Smith and David Smith were early sculpture heroes, especially the latter's *Cubi* series. In 1972 received a

National Endowment for the Humanities grant while still in school, not endearing me to the staff. I graduated in 1974 and shortly thereafter left the Ecumenical Institute.

1975 Was awarded a grant from the National Endowment for the Arts that required me to be in Wichita, Kansas, where I spent nine months building a series of large-scale formalist sculpture in aluminum and speaking to the public about contemporary art. Built six large abstract sculptures.

1976-80 Moved to Los Angeles settling in a turn-of-the-century fire station in downtown LA. I had finished with Modernism and began to equate it as one subculture among many. I thought maybe these other subcultures were worthy of sculptures and began researching various ones such as biker culture, low-rider culture, voodoo, etc. Began experimenting with altered mannequins in an effort to make figurative sculpture since I didn't have the skills, given my schooling, but the work seemed too close to Kienholz. Hit on the idea of working with taxidermy and began building a group of five sculptures using taxidermy and resin. Working title was "Extant Cultures," later to be redone as "New Myths and Heroic Metaphors." Released the first of the series—also my first figurative sculpture—*Vegas Jesus,* in 1979.

1981 *Vegas Jesus* shown at San Diego State University. Large demonstration at the opening against the work organized by right-wing Christian fraternity. Scathing articles and reviews confuse the sheep with a goat and speculate that it is a devil-worshiping sculpture. Event confirms my conclusion that there is something very powerful working figuratively.

1982 Began taking flying lesson at Santa Monica airport, simultaneously started putting wings on many sculptures: Pegasus, Sphinx, etc. Continued flight lessons off an on for many years finally becoming a commercial pilot in 1988.

1983 Walter Hopps comes to my studio looking at art for the sculpture show he is curating at MOCA in conjunction with the 1984 Summer Olympics. Fixes on *Pegasus* and later entitles the show "Automobile and Culture." Solo show at Otis-Parsons School of Art in Los Angeles showing the "New Myths and Heroic Metaphors." Audience in general was shocked at the dramatic change in my work from a few years earlier. Hostility from school staff, rave reviews in four newspapers.

1984 *Pegasus: Some Loves Hurt More Than Others* is chosen as the MOCA poster for "Automobile and Culture." NYC writer declines to include the piece in the show catalogue because he can't see how it fits in. Piece is published a couple hundred times over the next few years throughout the world. Moved to Brooklyn and found little interest in my work completing a personal crisis already in progress and I quit making art for about two years. Leased a plane and spent time island hopping around the northeast. Wasn't sure I would make sculpture anymore and looked into teaching aviation.

1985 Won the "Award in the Visual Arts" from the Southeastern Center for Contemporary Art (SECCA), mostly on the strength of the "Heroic Metaphors" work. Museums on show tour refused to take *Vegas Jesus,* citing the trouble it would cause. By November the award money was spent and, broke, I decided to work again. Wanted to cast a figurative sculpture but had no money for bronze. Went to the empty lot next door and dug up a wheelbarrow full of dirt and mixed it with glue to see if it would stick together. It struck me as the worst thing to do, to spend extraordinary labor on modeling dirt; it was Sisyphus shoving the rock, the only mood I was in. Surprisingly it did stick together, for how long I was unsure, but a few months would be sufficient I thought. Who cares. I made *Dirt Man With Fish,* the first dirt work. The dirt never fell apart and so I decided to make some more.

1986 Exhausted from the Dirt Man I decided to take a break and make something small. Made the first Dirt Baby, which I thought beneath publishability and stuck it under my workbench.

1987 Received a grant from the Pollock-Krasner Foundation. Made *Dirt Man with Dead Sphinx,* the only dirt man made off-scale. In this case about seven-and-a-half-feet tall. Finished casting the first edition of Dirt Baby sculptures and took some around to galleries. An infant made of topsoil seemed to be the last thing anyone wanted to look at in the roaring eighties, and I was shown the road. Didn't have a one-person show for six years after I started the dirt work.

1988 Was asked by the Aspen Design Conference, chaired by Jay Chiat and Henry Wolf, to build a large-scale sculpture for the annual conference whose theme was "The Edge: An examination of the state of things." I hit on the idea of making a house of simulated materials. All of it, every surface, accessory, furnishing and the like would be "fake," a sign pointing at a "real" product. Worked with six local architects to build it. Big hit at the conference.

1989 Met Christian Leigh. who took exceptional interest in the work. He asked if I had written anything, and I showed him a sprawling paper I had been pecking at for several years. Another Sisyphean endeavor summing up the history of worldviews:*The History of Everything.* He published it as part of the *Silent Baroque,* an anthology of contemporary art theory published in Europe. While in Salzburg, Austria, for the book party I saw the beautiful girl, Susanne Fellinger, an Austrian, and married her three months later.

1991 First New York City show at the age of thirty-eight at the Alcolea Gallery. Showed the Dirt Baby pieces, sold out. Show immediately travels to Berlin at Van der Tann. Begin showing regularly at this time. After the Dirt Baby show in the spring, I showed the Window series at Blum Helman in the fall and later at galleries in San Francisco and Boston. Well received critically but sales don't match the dirt baby pieces.

1992 *Dirt Man with Fish* appears as the November cover of *Sculpture* magazine, it was eight years old at the time and still never shown.

1994 Solo show of the Dirt Man series at Stux. Published *The Uncanny* in Amsterdam as a catalogue essay for "Babies and Bambies" at Maatschappij Arti et Amicitiae.

1995 Marriage failed and I divorced the following year. During this time I ran across an article in *The NY Times* describing a woman in Chicago who repeatedly used a stun gun to quiet a seven-month-old infant, ultimately killing him. This and many other clippings I found led me to believe that there was a sea change underway in our treatment of each other. Over the next year and a half I made the New Skins for the Coming Monstrosities series—beginning it five months before the Oklahoma City bombing. Once again no dealers in NYC would touch the work. I showed it at Galerie de la Tour in Amsterdam to great response. Thomas McEvilley writes a catalogue essay for the show entitled "Strategies for Survival." *Atlantica* magazine (Spain) does seven pages about the series. Began to write constantly during this time, completing two plays with Penn Young.

1996 Submit *Sea á Child* as a sculpture proposal for a new preschool in Oklahoma City to replace one destroyed in the blast. It is a landscape piece wherein a field is landscaped to appear as the sea and bronze dolphins jump through the "waves." Proposal well-received but lost out to swing sets. Make a conscious decision to turn away from classical guitar in favor of modern flamenco and begin studying with a Spanish gypsy, Enrique Vargas.

1997-98 I begin studying in earnest the sculpture of Rodin, trying to find ways to continue his point of view into our own times. I make many small sculptures, especially hands and arms, in trying to settle on a style of working similar to his but with contemporary emotion. The dirt technique seems to lend itself well to this. I had been fascinated by *Hombre y mujer* by Antonio Lopez-Garcia for some time and decided to re-do it, correcting what I believe to be errors such as stance and head size, etc. A six-month project working in clay from models portraying a middle-age couple. Ultimately the piece is cast in (what else?) dirt.

Selected Publications

Anna, Teresa. "Baby Boom." *The Virginian-Pilot*. January 1997.

Ballatore, Sandy. "James Croak's New Myths." *Images & Issues*. Winter 1984.

Bårtvedt, Alf. *Impressions*. (Oslo: H. Aschehoug & Co., 1996). p. 224.

Bonetti, David. "Gallery Watch." *San Francisco Examiner*. May 1995.

Boettger, Suzaan. "Dirt Works." *Sculpture*. November-December 1992.

Chiles, James R. *Smithsonian Magazine*. March 1985.

Coen, Michelle. "Reviews." *Artscribe*. Fall 1991.

Collins & Milazzo. Catalogue. *Across The River and Into the Trees*. June 1994.

Dorsey, Catherine. "Birth of An Exhibit." *Port Folio Magazine*. January 1997.

Drohojowska, Hunter. "Young Turks Review." *Artforum*. February 1982.

—. "Young Turks Review." *High Performance*. Fall 1981.

—. "The Artist Armed." *New West*. September 1982.

—. *James Croak: New Myths and Heroic Allegories*. (Los Angeles: Otis-Parsons, 1983).

Von Eckart, Wolf. "Auto Intoxication." *Time Magazine*. September 1984.

Fairley, John. *The Art of the Horse*. (New York: Abbeville Press, 1995). pp. 178-79.

Gardener, Colin. "Revising the Archetype." *Artweek*. November 1983.

Geer, Suvan. Review of "Spellbound." *Los Angeles Times*. October 1989.

Gottlieb, Katrien. *Het Parool,* February 1994.

Grootenboer, Doris. *Algemeer Dagblad*. February 1994.

Hagarty, Kathleen. *Los Angeles Times,* "Reviews," February 1982.

Hammond, Pamela. "Forms in Space." *Images & Issues*. March 1985.

Harrison, Hellen A. Review of "The Riddle of the Sphinx." *The New York Times*. November 1994.

Heartney, Eleanor. "Reviews." *Arts*. June 1984.

Iannacci, Anthony. "La Positiva Assenza di Originalità Nell' Arte." *Titolo* (Italy). October 1992.

—. "Niente di Nuovo." Segno (Italy) No. 115.

Jacobi, Tom. "Die Cowboys Haben Umgesattelt." *Stern* (Germany). March 1985.

Katz, Vincent. Review of "Dirt Man" exhibition. *ArtNews*. September 1994

Kirsch, Elizabeth. Review of "Ashes to Ashes Dirt to Dirt." *Kansas City Star*. May 1997.

Knight, Christopher. "An Artist Who Thrives on Disorder." *Los Angeles Herald Examiner*. July 1981.

—. "The Bizarre Art of James Croak." *Los Angeles Herald Examiner*. November 1983.

Kimmelman, Michael. Review of "The Dark Sublime." *The New York Times*. October 1989.

Kosher, Helen. "Nighttime Moves." *Artweek*. March 1980.

Marger, Mary Ann. "Art Beat." *St. Petersburg Times*. September 1995.

Mathews, Neil. "Heist of the Year." *California Magazine*. February 1982.

McEvilley, Thomas. "Strategies for Survival," catalogue essay from *New Skins for the Coming Monstrosities* (Amsterdam: Galerie de la Tour, 1996).

—. "The Millennial Figure." *Sculpture*. October 1997.

—. *James Croak* (Virginia: Contemporary Art Center, 1998, dist. Harry N. Abrams, Inc., Publishers, New York. 144 pp.).

Melrod, George. "Openings." *Art & Antiques*. June 1997.

Milani, Joanne. "Some scenes for a crisis." *The Tampa Tribune*. September 1995.

Meneghelli, Luigi. Review of "Niente di Nuovo." *Flash Art*. Summer 1992.

Monshouwer, Saskia. "Galerie de la Tour: Vitale Kunst." *Alert*. September 1996.

Munchnic, Suzanne. "Animal Magnetism." *Los Angeles Times*. November 1983.

—. "Lightning and Melodrama." *Los Angeles Times*. February 1980.

—. "MOCA Marks A Milestone." *Los Angeles Times*. December 1988.

Paul, Bob. "The Art of James Croak." *Esquire*. June 1984.

Plagens, Peter. "LA Roundup." *Art in America*. April 1985.

Salgado, Michael. "Pick of the Week." *L.A. Weekly*. November 1983.

Stapen, Nancy. Reviews. *Boston Globe*. March 1994.

Stigter, Bianca. *Handelsblad*. February 1994.

Smith, Edward Lucie. *American Art Now*. (New York: William Morrow & Co. Inc., 1985). Frontispiece.

Sozanski, Edward. Review of "Child's Play." *The Philadelphia Inquirer*. October 1991.

De Vries, Marina. "Madurodam van Landart." *Het Parool*. April 1997.

Watten, Barrett. "A Condition of Loss." *Artweek*. January 1992.

Welchman, John. "Peeping Over the Wall." *Narcissism: Artists Reflect Themselves*. (Escondido: California Center for the Arts Museum, 1996). pp. 19-20, 29, 60.

Wilson, William. "The Automobile as Artistic Challenge." *Los Angeles Times*. July 1984.

—. "Ars Longa," Review of "Automobile & Culture." curated by Walter Hopps. *Los Angeles Times*. August 1982.

—. "California Sculpture Dreaming." *Los Angeles Times*. August 1982.

—. "Reviews." *Los Angeles Times*. July 1980.

—. "Reviews." *Los Angeles Times*. September 1978.

Those who have crossed

With direct eyes, to death's other Kingdom

Remember us—if at all—not as lost

Violent souls, but only

As the hollow men

The stuffed men

T.S. ELIOT, "THE HOLLOW MEN"

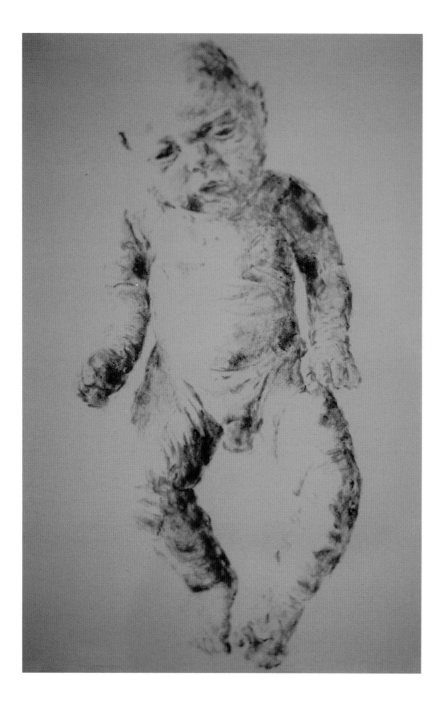

Study for Dirt Baby

1988

16 x 14 inches

Dirt on paper

Collection of Arlene and

Barry J. Hockfield

Afterword

The malaise of our time, its hollowness and violence,
is reflected in the sculpture of James Croak. Like a number of significant artists at this century's end, Croak utilizes the figure, which conceptually functions as metaphor for the body, the locus of desire and mortality. From his earlier mythologically inspired constructions to his more recent figural sculptures, Croak's work seems to resonate between two conflicting drives: the death instinct (Thanatos) and the libido—the raw life force that seeks satisfaction and expansion (Eros). By utilizing a range of materials—skins and taxidermy forms, cast dirt, and skinlike latex—Croak transforms historical and cultural references into viscerally powerful statements and unblinkingly reveals the anesthetized consciousness of modern humankind.

Croak first began exploring the figure through experimenting with skins and taxidermy forms, creating mythological hybrids. His 1982 *Pegasus: Some Loves Hurt More Than Others,* a full-sized taxidermied horse with unfurled wings lunging into flight from the interior of a Chevy lowrider, is an exuberant expression of Eros-desire. The escaping Pegasus is the instinctual drive that cannot be contained within the mechanized vehicle; it is the spirit contained within the material world that is propelled toward life and immortality. Likewise, *Lioness,* 1982, seems to be inspired by the instinctual, generative source of life that is both fierce and cunning.

The artist's work gradually evolved from dramatic, heroic expressions of the instinctual to more solitary, introspective musings. By the late 1980s, Croak abandoned working with skins, and his exploration of materials led him to work with dirt, a material that is humble, accessible, and purportedly "neutral." Dirt—sullied earth, urban detritus or decay—is base material. The notion of fertility, however, cannot be denied. Therein lies the paradox of much of Croak's dirt-based work.

One of the early sculptures Croak made from cast dirt is *Wing,* 1989, a feathered span associated with air and flight now "grounded." The wing so heroically articulated in Pegasus is now made from earth, soiled and weighted so that transcendence is no longer possible. Croak masterfully inverts themes—the mechanism of flight and transcendence is cast back into matter. "Grounded matter" is a continued theme in Croak's Dirt Baby series. These newborn-sized figures are fraught with tension. At once the sensual tactility of the material is juxtaposed with the disturbing content of an infant's foreshadowed mortality. As noted by one writer, "all of a baby's connotations of purity, innocence and promise are contradicted by dirt's association with filth, defilement and refuse. Croak's numerous dirt offspring suggest an identification with an emotionally battered child; what has been refused here, so to speak, is the hopefulness that newborns inspire."[1] These infants seem more about survival than inspiration and this sentiment is continued in their adult version, the Dirt Men series."

Clothed in business suits and fedoras, Croak's life-sized Dirt Men reflect the displacement of humanity and the hollowness of existential "everyman." These enigmatic figures seem to reside in two realms—evoking the irrational intensi-

ty of a dream and the despondent response to a deadening reality. One figure is slumped, decidedly anti-heroic, losing a battle for survival, his outstretched leg already decomposing back into the earth. Perhaps inspired by Croak's gruesome encounter with a corpse of a murdered homeless man propped against his studio door in West Los Angeles, this imagery is a visceral commentary on fatal assaults on homeless individuals.

More recently Croak has returned to the notion of "skins" conceptually functioning as protective armor in his New Skins for the Coming Monstrosities series. Inspired by newspaper articles chronicling the incidents of violence and abuse, this series draws attention to the many situations that call for camouflage and protection from the "danger zone" of everyday life. Devoid of the human figure, *Interpersonal Relationship Suit,* 1995, is a life-sized cast latex that is encrusted with stones. This suit implies that to interact with another is to make one's self vulnerable to psychological, physical, and emotional "stone throwing." It is wryly suggested that one may escape seclusion by donning armor already covered with stones, the raw skin is obscured and protected. Likewise, *Trash Suit,* 1995, is suggestive of human skin encrusted with wrappers, crushed bottles, and smashed cans. This suit is about the plight of the homeless, socially identified as urban detritus. The individual and trash are melded into one, the trash serves as camouflage to protect this "endangered species." This suit may also be a commentary on consumer society's cycles of acquiring, consuming, and discarding at the expense of creating a dwelling place that is polluted and contaminated.

Throughout Croak's twenty-year oeuvre, he has examined the cultural values of disposable society, its effects on consciousness, nature, and the future. A society that believes material surroundings are inorganic, lifeless, and dead will perpetuate cycles of demolition, not preservation. A society that sees the body as no more than a machine, with the reflective ego residing in the head, in the eyeballs, results in an incredible isolation of individuals and of consciousness. The result of these cultural values is a collective drive toward Thanatos—death, violence, and destruction. Although Croak's sculpture mirrors the negative mood of the age that is rampantly violent, he does not give up completely. His most recent work returns to the significant fragment and classical figure. In this work there is a hint of the heroic, of transformation and of "body ensouled." Figures of men or women are modeled by the artist's hands, cast in dirt and are made with inspiration and intent.

Perhaps dispelling the myth of eternal youth, Croak's recent subject matter is the body past its idealistic prime, but nonetheless propelled toward life and desire—Eros. Through his passion for the figure's expressive capacity Croak conveys experiences in and of the body. By delving beneath the skin, he seeks to reveal matter imbued with spirit, liberating a certain energy that seeks satisfaction and expansion as antidote to hollow deadness.

CARLA MARIE HANZAL

1 Suzaan Boettger, "Dirt Works," *Sculpture,* December 1992, p. 41.